10 BUILDINGS THAT CHANGED AMERICA

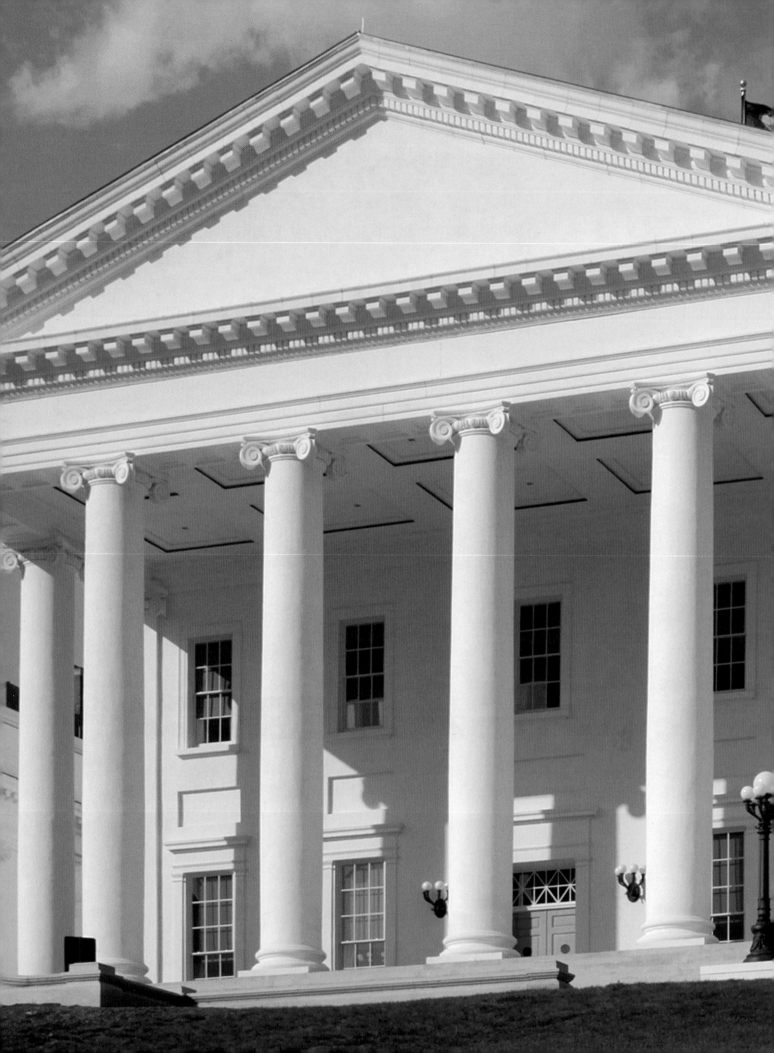

10 BUILDINGS THAT CHANGED AMERICA™

COMPANION TO THE PBS SPECIAL WRITTEN BY **DAN PROTESS** WITH **GEOFFREY BAER**

wttw
CHICAGO

MIDWAY

AN AGATE IMPRINT

CHICAGO

Design by Brandtner Design

Printed in the United States of America.

Library of Congress Cataloging-in-Publication Data

Protess, Dan.
10 buildings that changed America / by Dan Protess with Geoffrey Baer.
 pages cm
 Includes bibliographical references and index.
 ISBN 978-1-57284-135-2 (hardback) -- ISBN 978-1-57284-724-8 (ebook)
 1. Architecture--United States. 2. Architecture and society--United States. I. Title. II. Title:
Ten buildings that changed America.
 NA705.P76 2013
 720.973--dc23
 2013010297

10 9 8 7 6 5 4 3 2 1

Midway is an imprint of Agate Publishing. Agate books are available in bulk at discount prices. For more information, go to agatepublishing.com.

TABLE OF CONTENTS

INTRODUCTION

If you were going to pick 10 buildings that changed America, which ones would be on your list? That's the question producer Dan Protess and I posed to ourselves as we set about to make a one-hour TV special of the same name for PBS. This book is the companion to that program.

The list we put together is wildly eclectic. It runs the gamut—from breathtaking works of built art, like Frank Gehry's Walt Disney Concert Hall, to a building type that has become so ubiquitous it's almost mundane, the shopping mall. We also included a factory, a house of worship, a prototypical skyscraper, a state capitol, and two homes.

So how did we arrive at this list? It wasn't easy.

First, Dan and I had to define what we meant by the phrase "changed America." The program was about architecture, so we were not focused on buildings that changed America by virtue of what happened inside of them—the White House, or Sun Studio in Memphis, for example. Instead, we were in search of revolutions in building design that influenced the way we live, work, worship, learn, shop, and play. From the beginning we knew we weren't assembling a top-10 list. It couldn't be *the* 10 buildings that changed America because, of course, there have been far more than 10.

Second, we gave ourselves other criteria: only buildings that are still standing; no more than one building by any architect; no more than one building in any city; and diverse building types, geography, and historical periods. To further narrow the list, we decided to include only buildings built after America became independent from Great Britain.

Third, to help us in our quest, we recruited 17 architectural historians who served as our panel of advisors. We also sought ideas informally from a wide network of architects and other experts. Dan spent several months researching the buildings, which we discussed and debated. As you can imagine, the final list evolved from a great deal of horse-trading and lots of very painful decisions.

With our list assembled, it was time we hit the road.

Dan and associate producer Lisa Goepfrich planned a grueling travel schedule. For more than three months, we crisscrossed the country with our talented director of photography Tim Boyd. We recorded lengthy on-camera interviews

with 24 people, including architects Frank Gehry, Robert Venturi, Denise Scott Brown, and Phyllis Lambert (who chose Ludwig Mies van der Rohe to design the Seagram Building in New York). Tim's camera lavished attention on every divine detail of the buildings on our list.

When we returned to home base—public TV station WTTW in Chicago—Dan began reviewing all the footage and writing the script, which he and I refined together. Our team scoured archives to find just the right historic photos and film footage. Dan spent many more months sequestered in an editing room, boiling everything down into a single hour of television. This epic journey ended with the airing of *10 Buildings That Changed America* on PBS in May 2013.

But in a sense, the TV debut was only the beginning.

There's so much more to our story than we could tell in a one-hour program. This book and the website—www.wttw.com/10buildings—give us the space to share more and, we hope, spark a public conversation about buildings and how they affect us all.

We hope that *10 Buildings That Changed America* will be just the first in a long series and that future programs, books, websites, and other projects will allow us to journey even further back in time to feature an even wider range of the built-environment in more parts of the country.

Geoffrey Baer

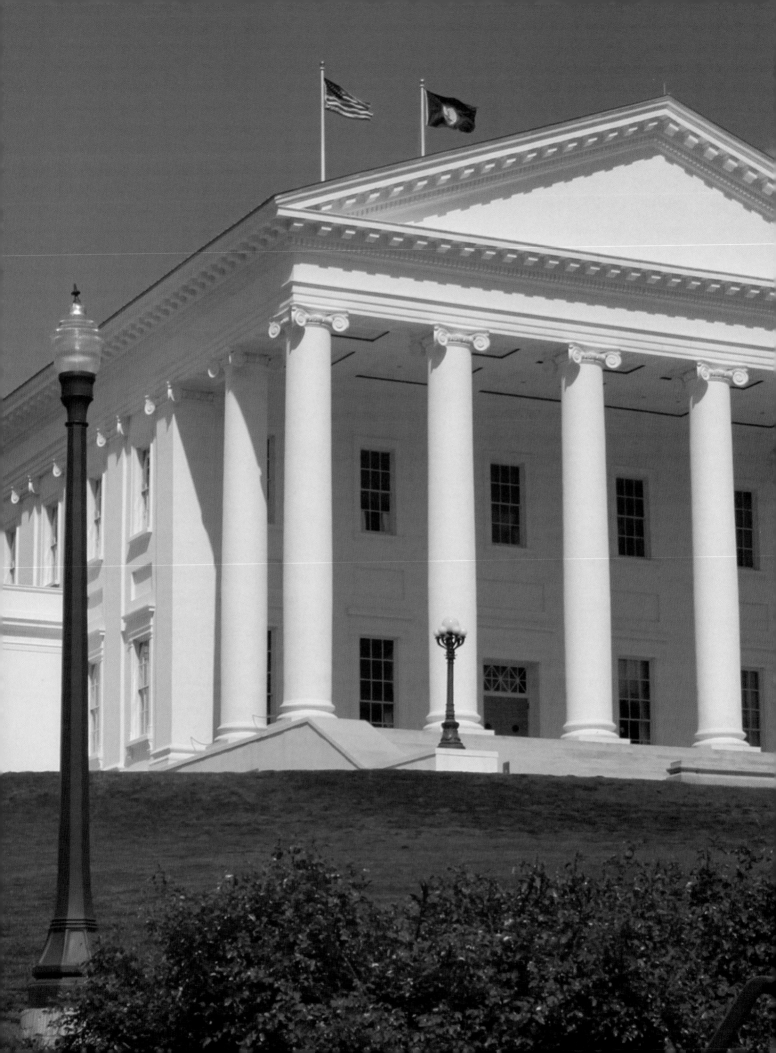

1

VIRGINIA STATE CAPITOL

- RICHMOND, VIRGINIA
- THOMAS JEFFERSON, 1788

In big cities and small towns across America, government buildings often look like Greek and Roman temples. This tradition began in Richmond, Virginia, the home of the oldest of our 10 buildings that changed America.

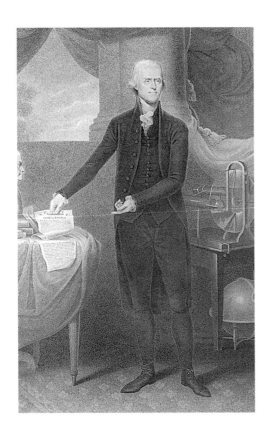

Thomas Jefferson (above), a self-taught architect as well as a founding father, was living 4,000 miles away in France when he designed the Virginia State Capitol. When he returned to Richmond, he found his building had been altered significantly (right). It had been enlarged, the offices had been moved to the basement, and the grand front steps had been eliminated. Jefferson was deeply disappointed when he saw it.

Jefferson, who authored the Declaration of Independence, considered this building to be, in a sense, his declaration of architectural independence from Britain. He never liked the colonial, Georgian architecture of Virginia, which had been imported from Britain and named for its kings. It offended his sense of style as an architect, and it clashed with his politics as a revolutionary.

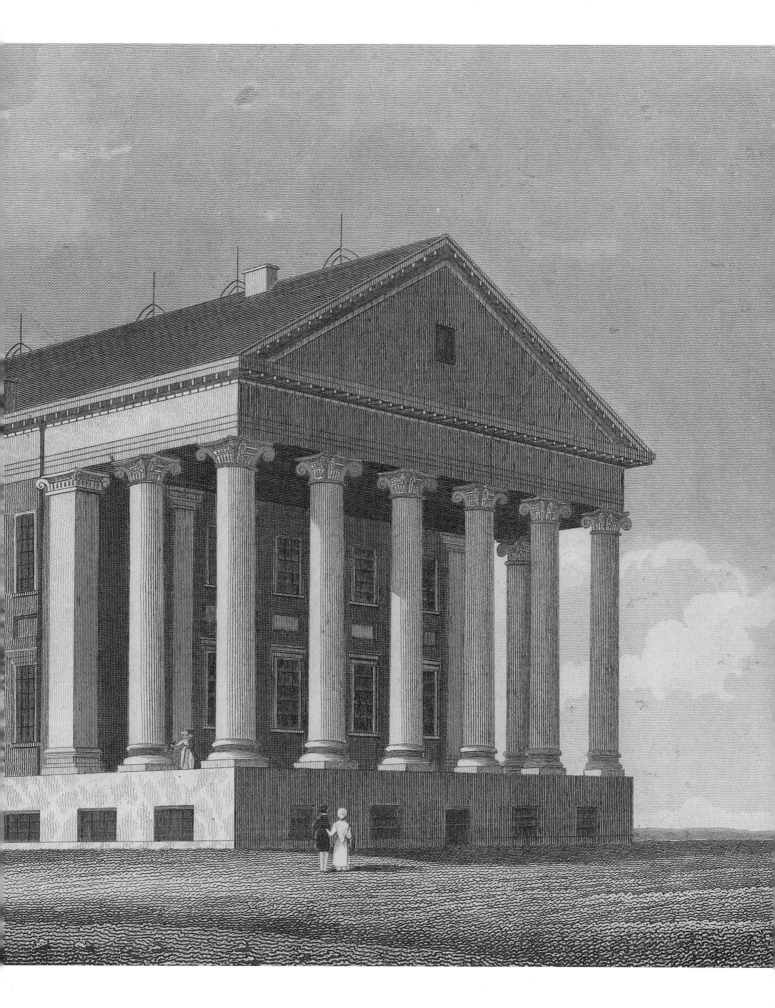

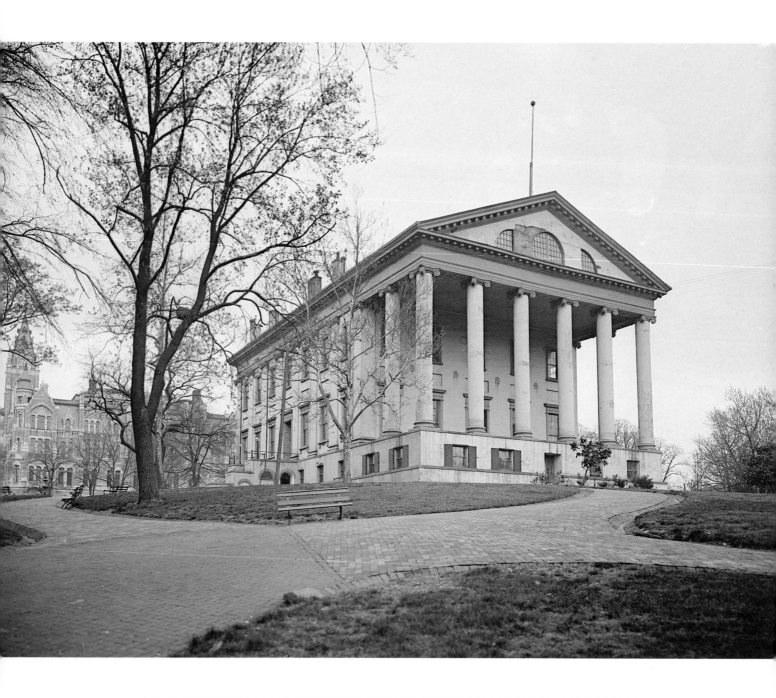

[It] was always intended that there would be these magnificent front steps that you would come up from the river, come up this hill, there would be this temple on the hilltop.... This is supposed to be a noble structure, this is supposed to be a symbol of government, and of the new democracy, the new Republic, of the State.

—RICHARD GUY WILSON
Professor of Architectural History, University of Virginia

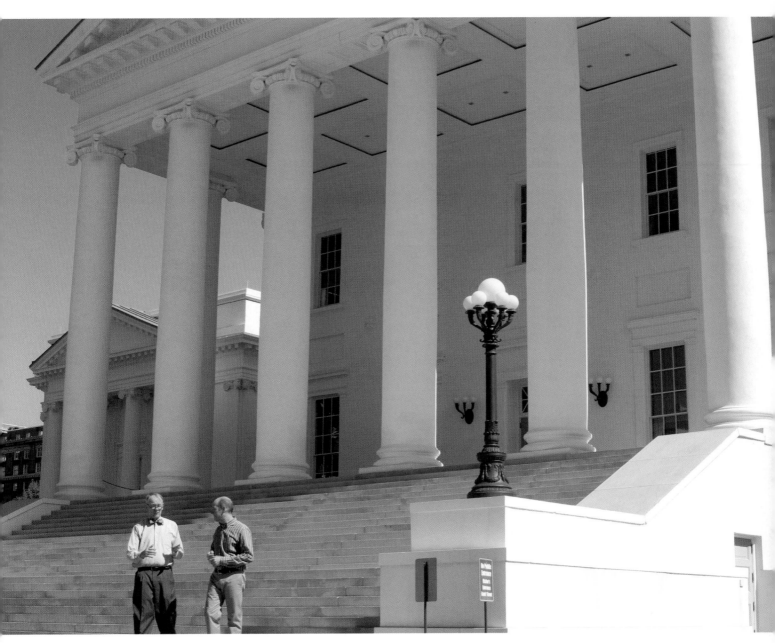

Richard Guy Wilson (left) and Geoffrey Baer on the Virginia Capitol front steps, which were added long after Jefferson's death.

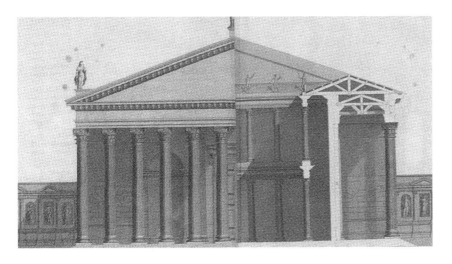

Jefferson was invited to create this new face for Virginia while he was serving as America's minister to France. But he didn't find his architectural inspiration in the court of King Louis XVI. Instead, he looked back to the great classical buildings of Rome (left), which he knew from his architecture books.

[Jefferson] was very much interested in Greece and Rome. He spoke Latin and he spoke Greek. And men of that class looked to the ancients as providing a template, as a model for something that was universal. He liked the clean lines, he liked the symmetry, and this was his statement about the new nation being a part of the Western world but not being beholden to Great Britain.

—**ANNETTE GORDON-REED,** Professor of History, Harvard University

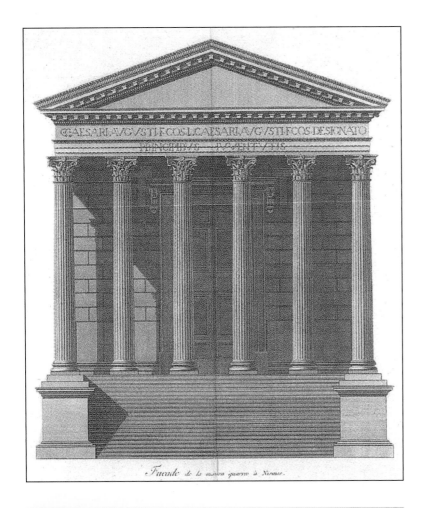

Façade de la maison quarrée à Nismes.

Rather than simply borrow ideas from the ancients, Jefferson decided to do something unheard of: design the Virginia State Capitol as a copy of an actual Roman temple—the Maison Carrée in the South of France. He wrote somewhat lasciviously about his first face-to-face encounter with the temple: "Here I am...gazing whole hours at the Maison Carrée, like a lover at his mistress."

The Maison Carrée (left, top) is a one-room, windowless temple—not an ideal vessel for state government. With the help of French architect Charles-Louis Clérisseau, Jefferson made a few practical changes to his design. While the Maison Carrée sported fancy Corinthian columns, he thought that the workmen in Virginia could only handle simpler, Ionic columns (left, bottom).

Jefferson placed a statue of America's first president (opposite page) in the rotunda—the same spot where the Romans might have placed a statue of a god. Most Americans think of George Washington as the somber figure pictured on the dollar bill. But the Virginia State Capitol statue is considered a more accurate likeness: It was created using a mold of Washington's face.

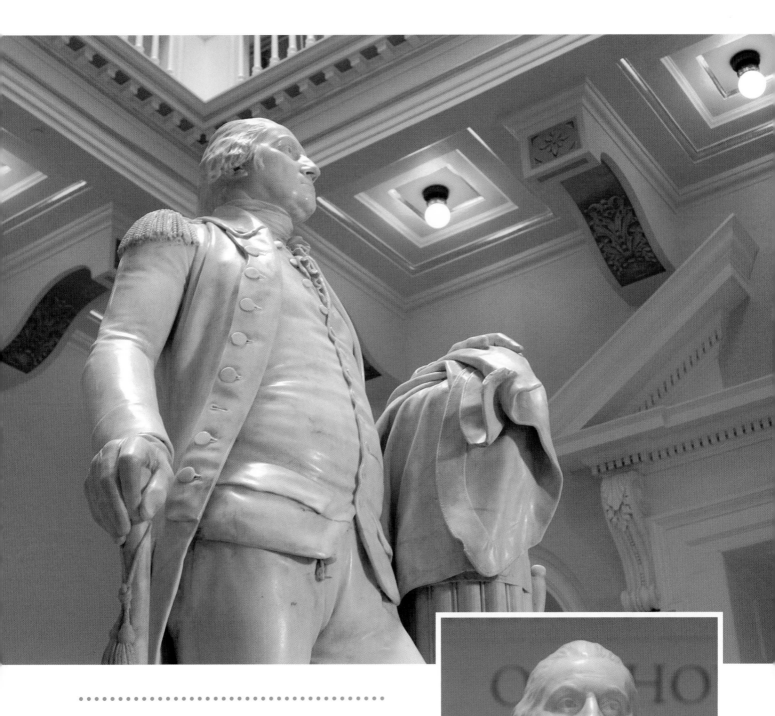

[Washington] is not presented as a king. He is presented as a gentleman...a real-life individual.... He's missing a button here and there. He's got some ruffles.... It's not just this perfect type of a form.

—RICHARD GUY WILSON

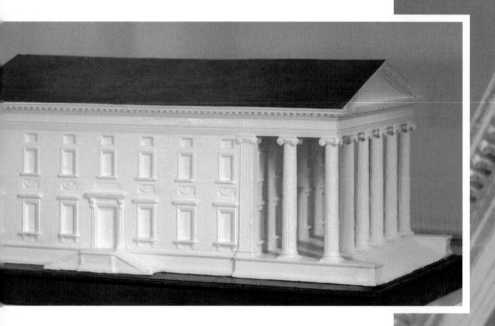

Even though Jefferson was an ocean away in France, he tried to micromanage construction of the capitol. He shipped a scale model (above and right) and detailed drawings of the building to Virginia. But Jefferson's attempts to oversee the project from afar fell apart. His plans took months to reach Richmond. In the meantime, legislators grew impatient, and the builder broke ground using an entirely different design. When Jefferson's plans finally arrived, the builder adapted them to fit the existing foundation, and took other liberties, such as omitting the grand front steps, which wouldn't be added until long after Jefferson's death.

Jefferson's vision may not have been fully realized, but his decision to model the Capitol after an ancient Roman structure had a lasting impact on American architecture. The Virginia State Capitol inspired American architects to use the classical temple form as the official face of the new nation.

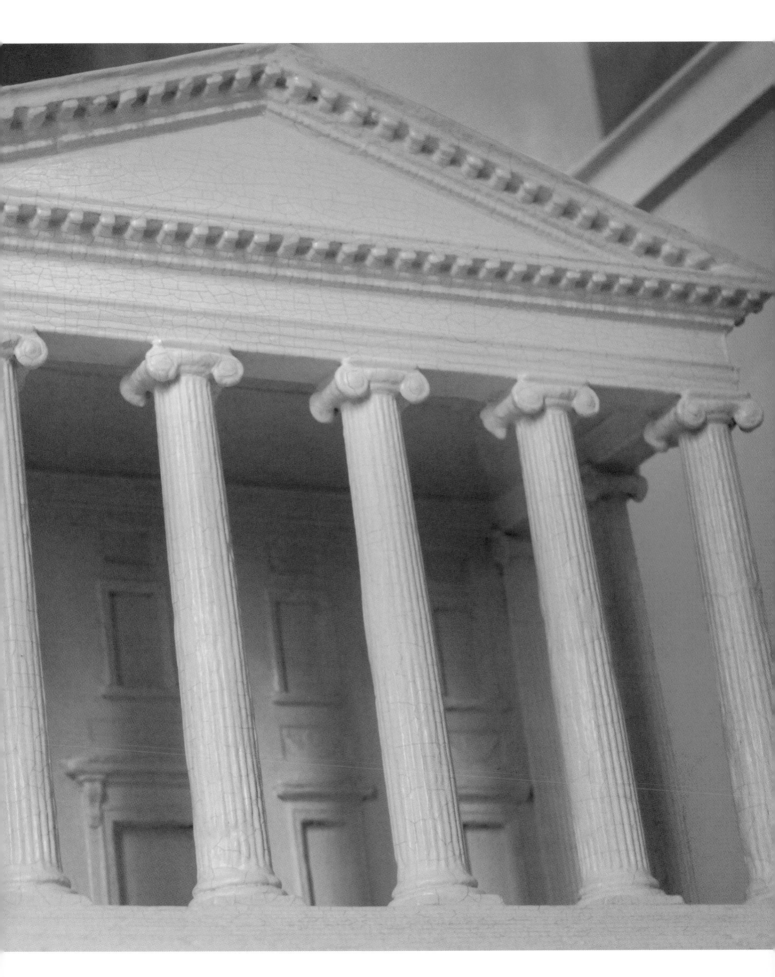

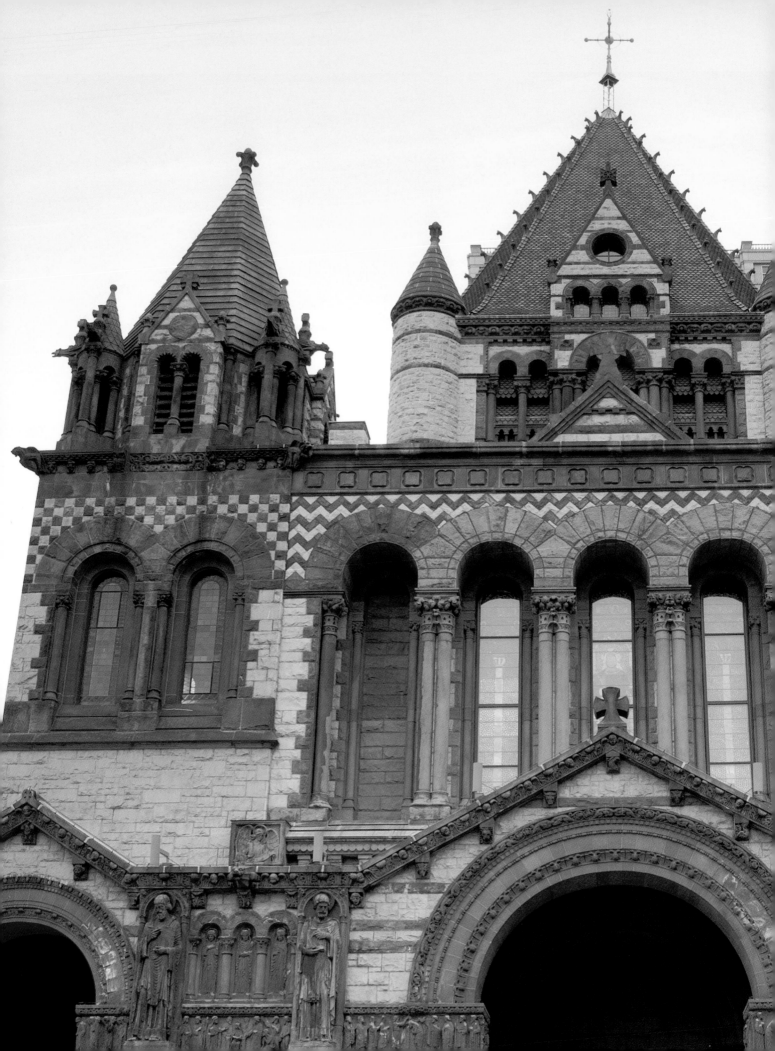

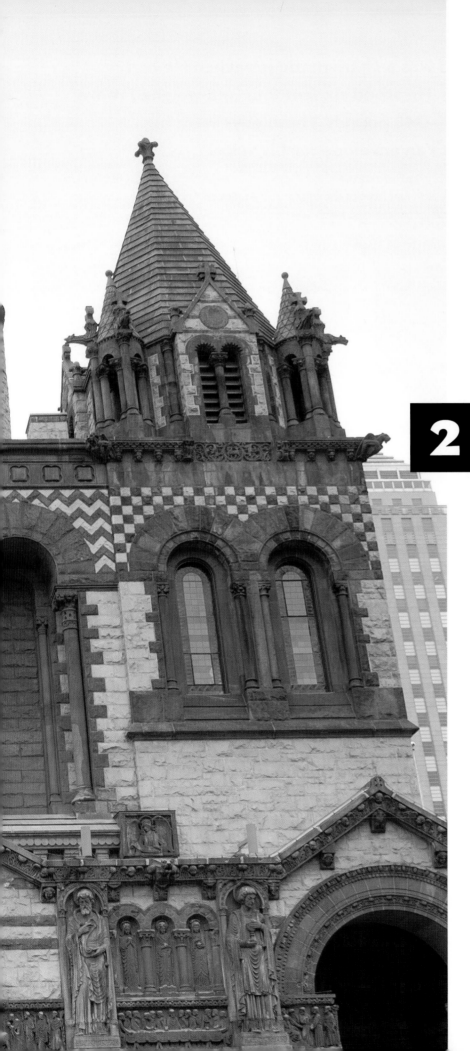

2

TRINITY CHURCH

■ BOSTON, MASSACHUSETTS
■ H. H. RICHARDSON, 1877

Wherever you go in America, you will probably see buildings that look like Boston's landmark Trinity Church. Its heavy walls of rough-faced stone, round arches, and massive towers are echoed in churches, city halls, and post offices across the country. It's a style called "Richardsonian Romanesque," after Trinity's architect, H. H. Richardson.

[Phillips Brooks] was a charismatic preacher. He had penetrating eyes. He stood six feet four and weighed more than Richardson—340 pounds. These guys were big.... [The church was] an envelope for his voice.

—JAMES F. O'GORMAN
Grace Slack McNeil Professor Emeritus of the History of American Art, Wellesley College

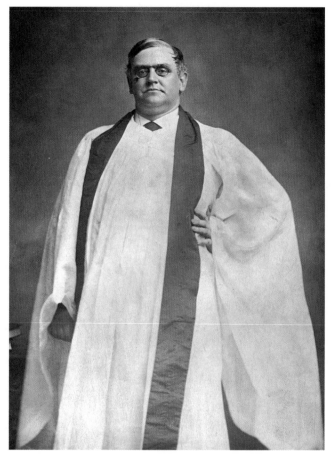

H. H. Richardson (above, left) became so well known for his architectural work and striking appearance (he weighed more than 300 pounds and posed for pictures in a medieval monk's robe) that he achieved celebrity status in the 1880s. His chance to change the face of American architecture had come when he was just 33, when he was invited to compete for the job of designing Trinity Church. When he received the invitation, he flipped it over and sketched an initial design on the back (opposite page). The essence of Trinity's final design can already be glimpsed in this remarkable initial sketch.

Richardson created his winning design with one man in mind: the church's rector, Phillips Brooks (above, right). Brooks is best remembered as the writer of the Christmas carol "O Little Town of Bethlehem," but in his time he was known as a spellbinding preacher who drew enormous crowds.

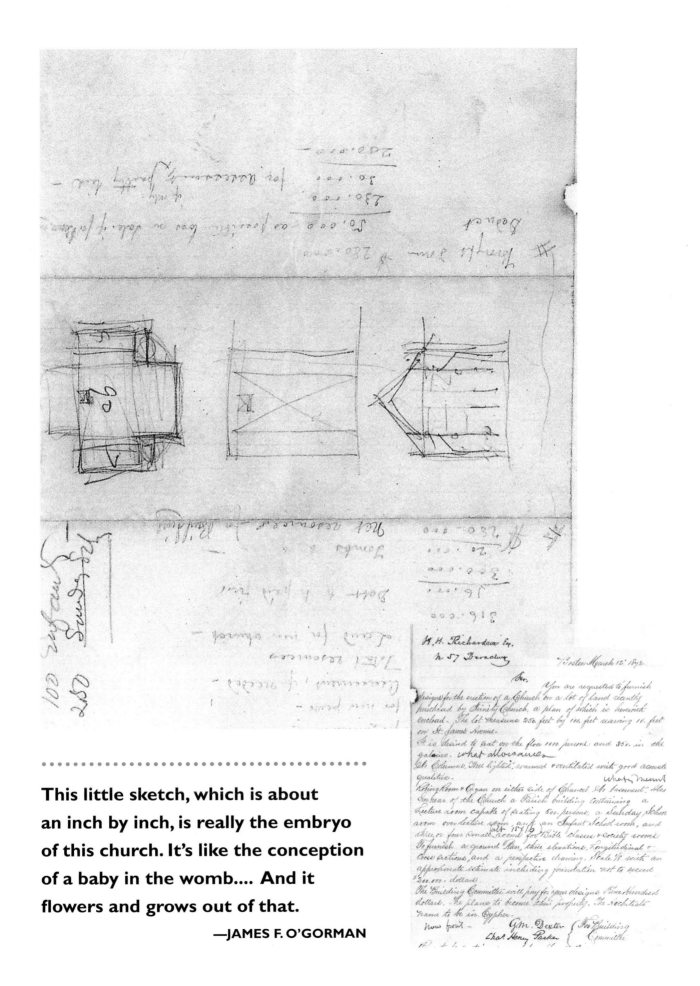

This little sketch, which is about an inch by inch, is really the embryo of this church. It's like the conception of a baby in the womb.... And it flowers and grows out of that.

—JAMES F. O'GORMAN

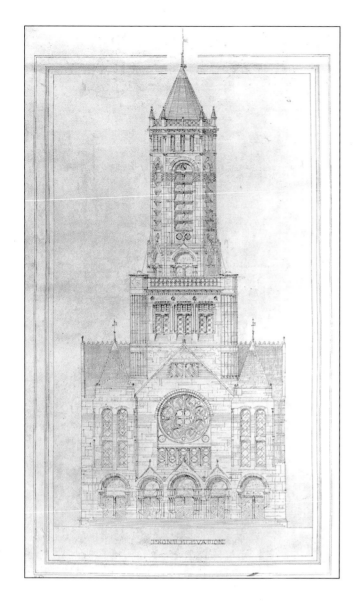

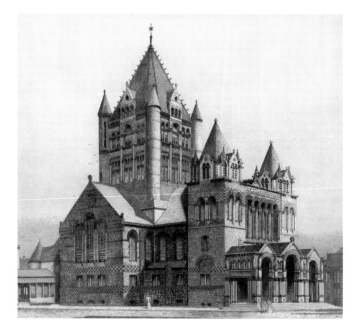

It's a fantastic kind of architecture. It's very massive. It's heavy.... It's a great square pile, effectively, in that plaza, with these fantastic arches and this articulated masonry that really looks as if it was chiseled right out of rock on the site.

—REED KROLOFF
Director, Cranbrook Academy of Art and Art Museum

Richardson structured the church as a compact cross, which enabled the more than 1,400 parishioners to gather *around* Brooks. The sanctuary was decorated by some of the greatest American artists of that era.

Trinity Church was originally designed with a tall spindly tower (above, left). But the building's engineers knew that idea was literally on shaky ground—the church was built on the unstable surface of Boston's Back Bay, a manmade piece of real estate that had been created by filling in a former marsh with gravel and sand. In response, Richardson adopted what became Trinity's defining feature: a broad, earthbound tower (above, right).

The tower is held up by four piers, which run down through the corners of the sanctuary (opposite page) so that they won't block views of the preacher. The piers are supported by huge granite footings below the church (opposite page, inset). The footings, in turn, rest on 4,500 wood pilings—essentially, tree trunks—driven into the gravelly ground.

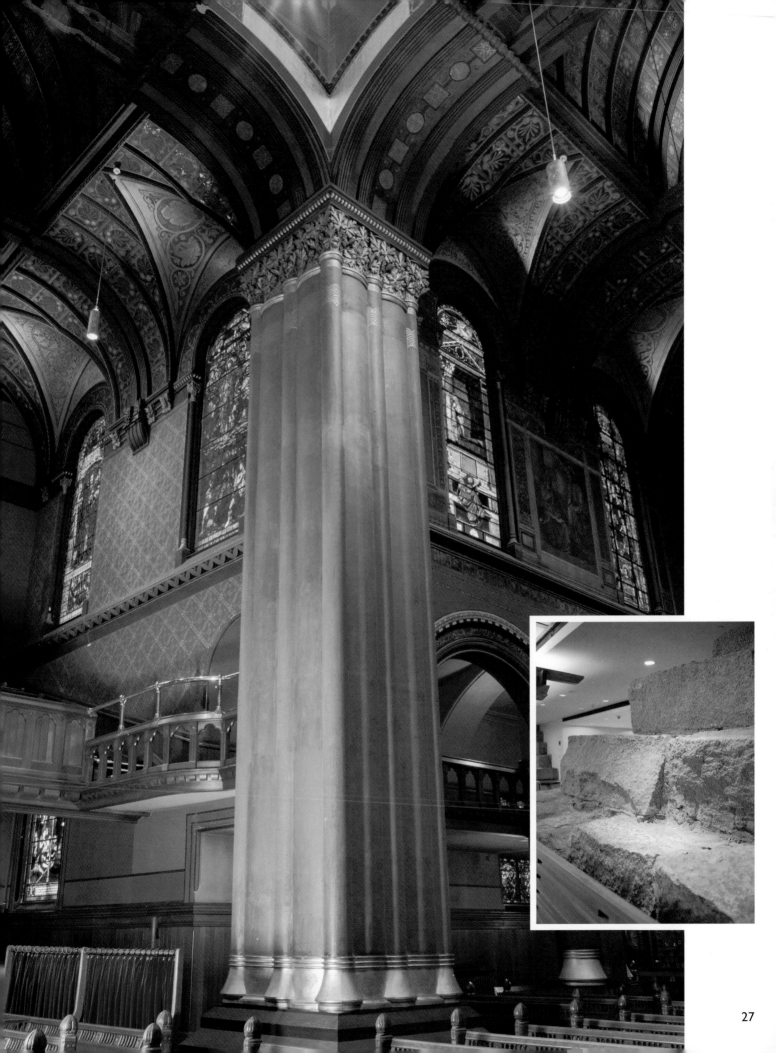

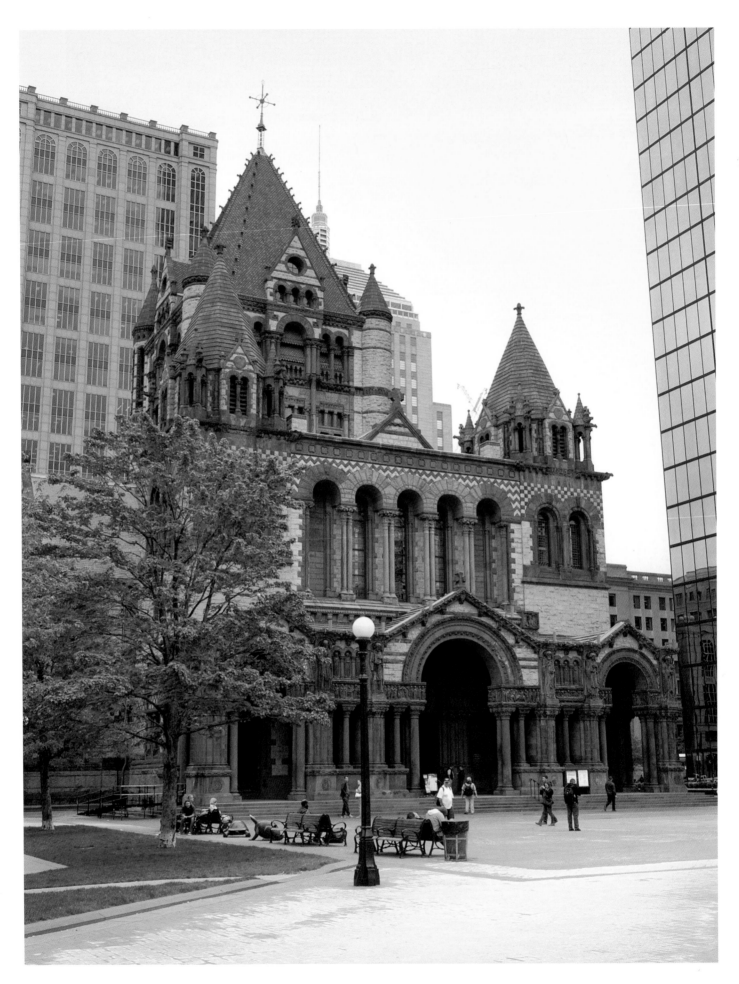

CHAPTER 2: **TRINITY CHURCH**

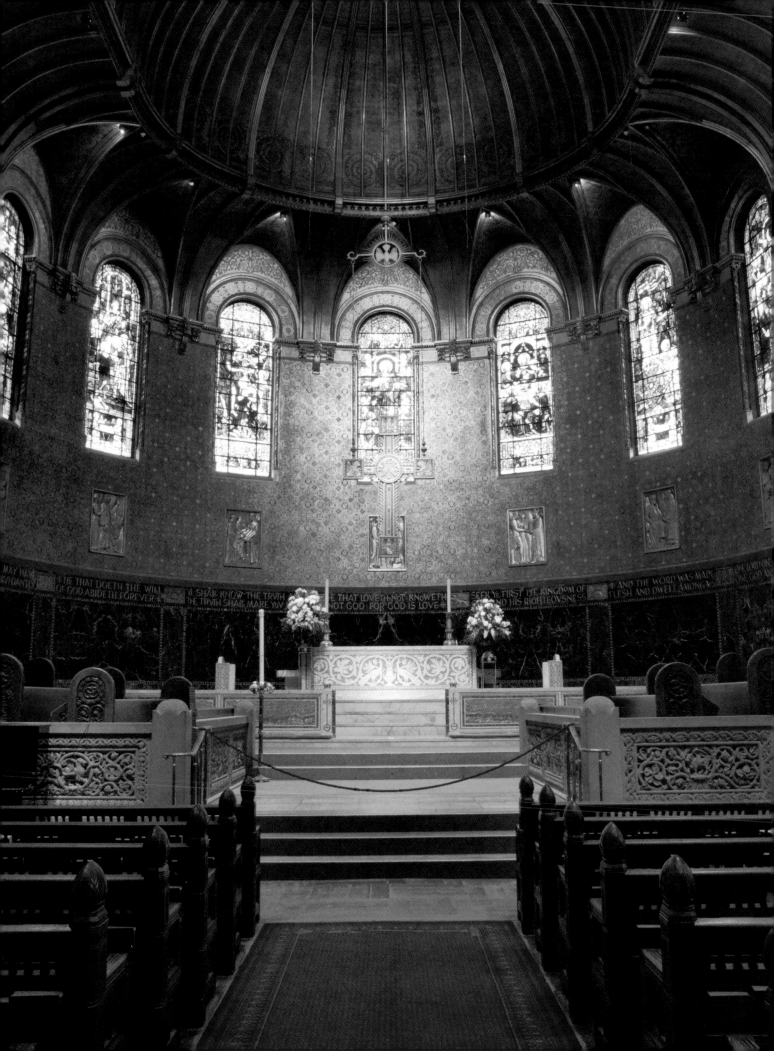

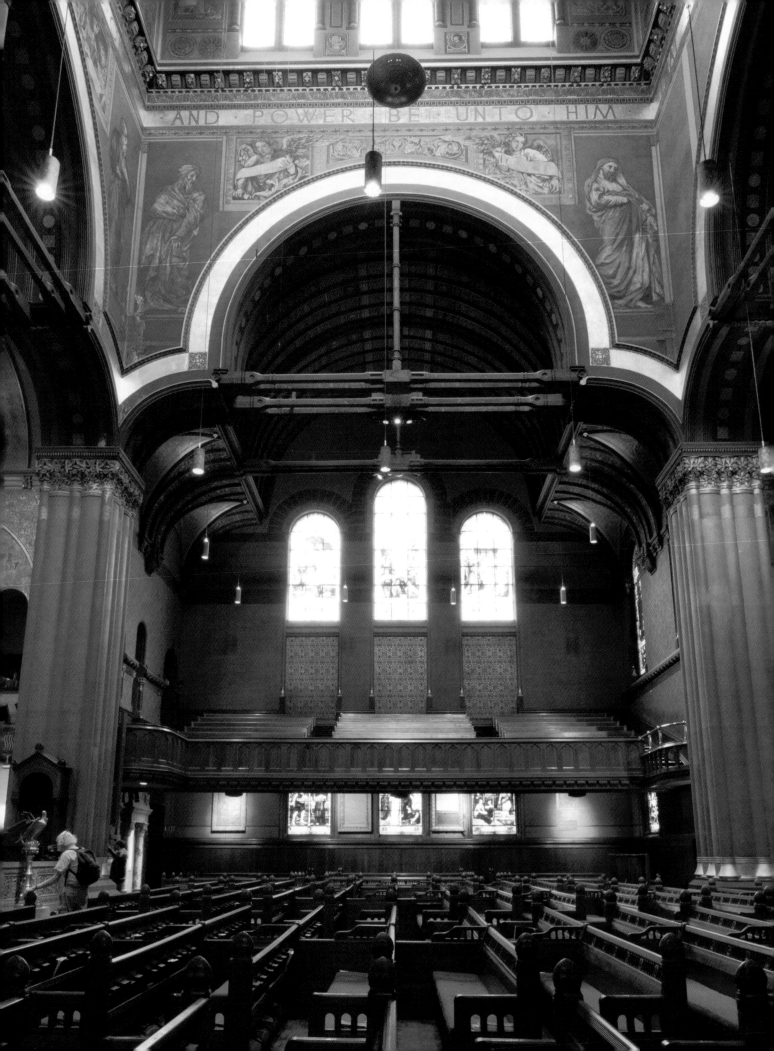

AND · POWER · BE · UNTO · HIM

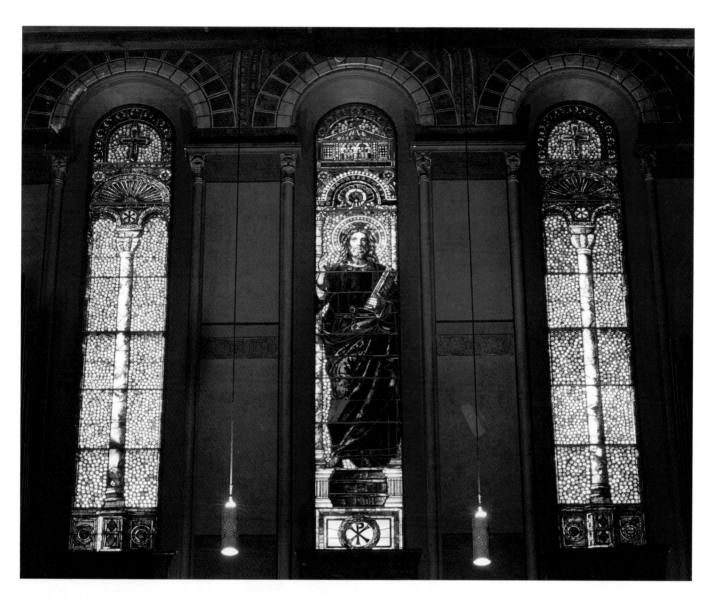

It's a space that draws you in and invites you to both experience a sense of awe... and also a sense of intimacy.... You walk in and you immediately feel that you're part of a congregation, that you're part of a grouping of individuals who are there to share a space together.

—TED LANDSMARK,
President and CEO, Boston Architectural College

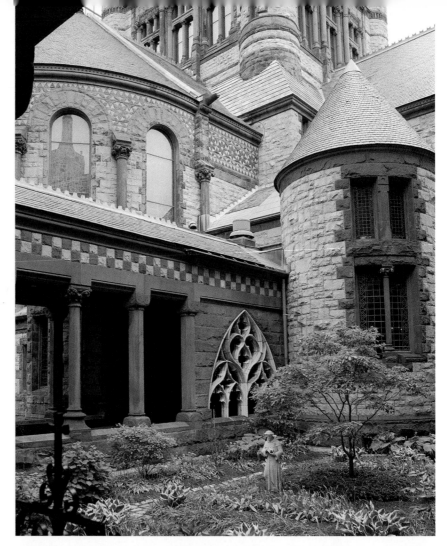

The broad tower and boxy sanctuary come together to make a mountainous form, which Richardson married with his interpretation of the muscular Romanesque style of medieval Europe. The architectural result was entirely new: Richardsonian Romanesque has Old World roots but was transformed into something that was fresh and distinctly American. It grew out of the so-called American Renaissance, when the nation's painters, writers, and architects were all enjoying a new golden age.

Although Richardson lived only nine more years after Trinity Church was completed, he continued to refine his style, and designed many notable works of American architecture before dying from kidney disease at just 47 years of age. The Richardsonian Romanesque style born at Trinity Church was adopted by other architects and, in the words of Cranbrook Academy's Reed Kroloff, "It took America by storm."

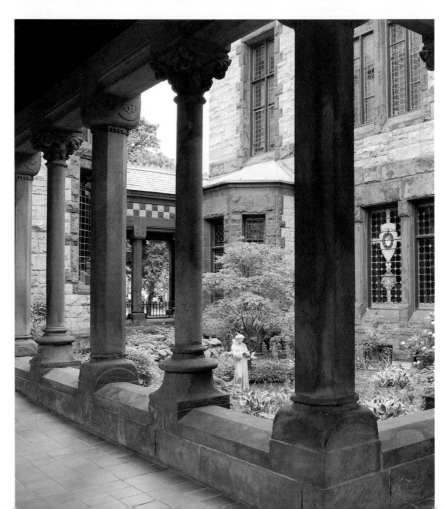

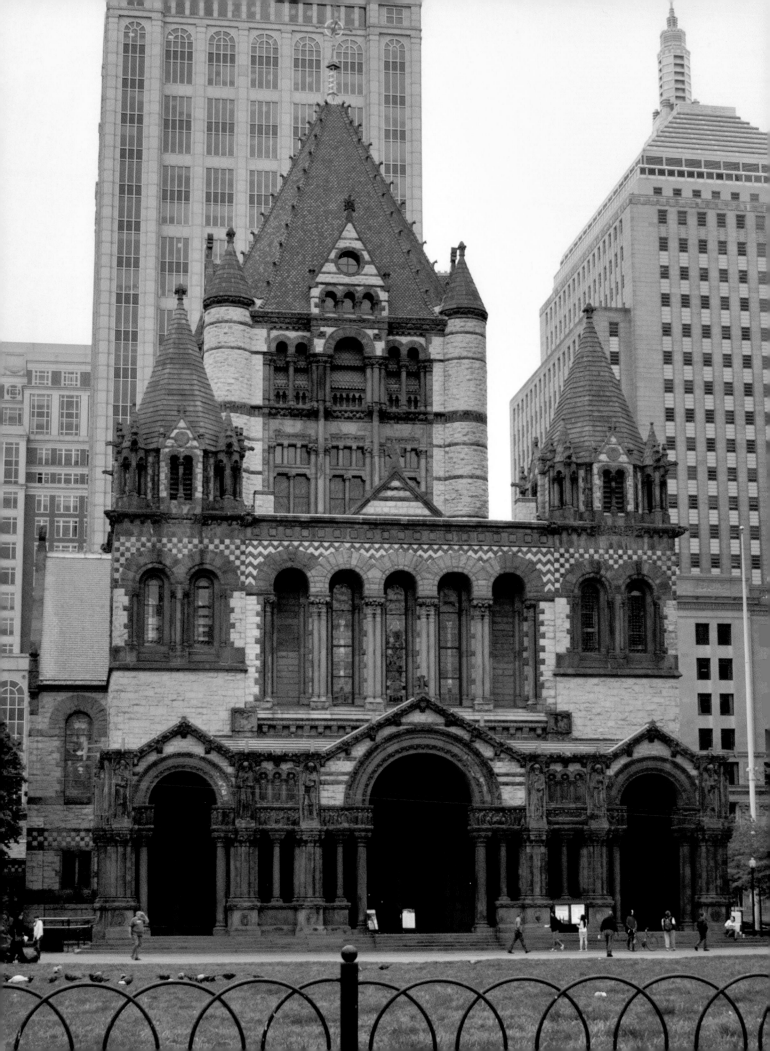

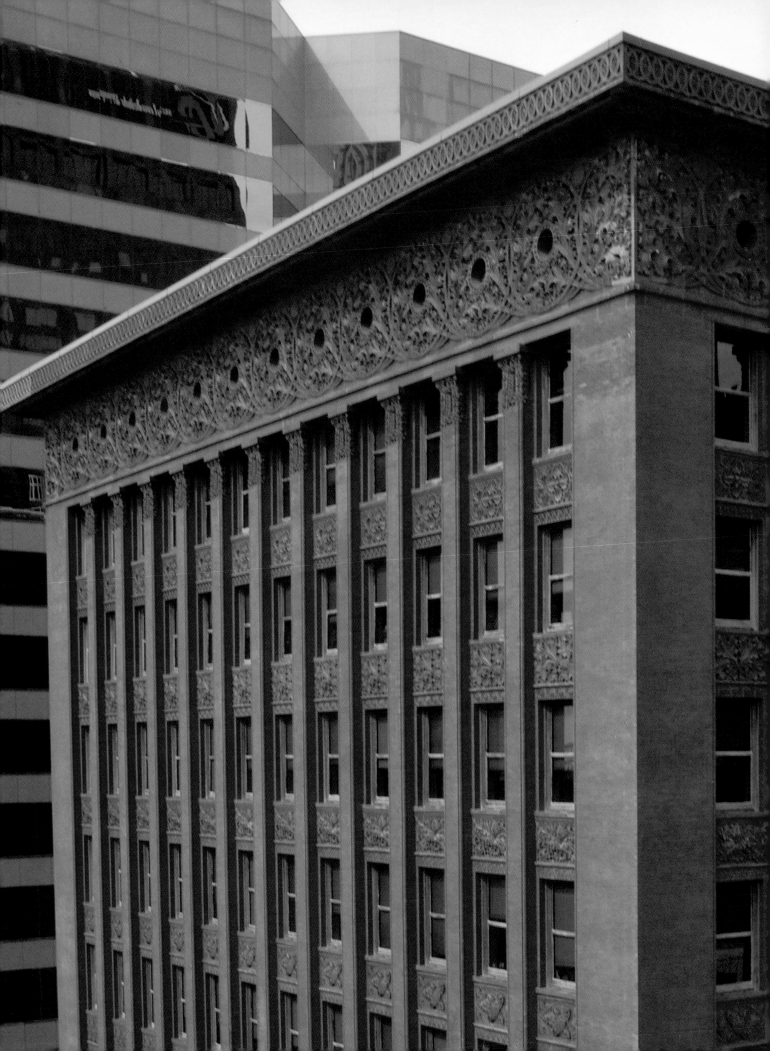

3

WAINWRIGHT BUILDING

- ST. LOUIS, MISSOURI
- LOUIS SULLIVAN, 1891

It might seem obvious that skyscrapers should *look* tall. But they never did until this St. Louis tower reached toward the heavens in 1891.

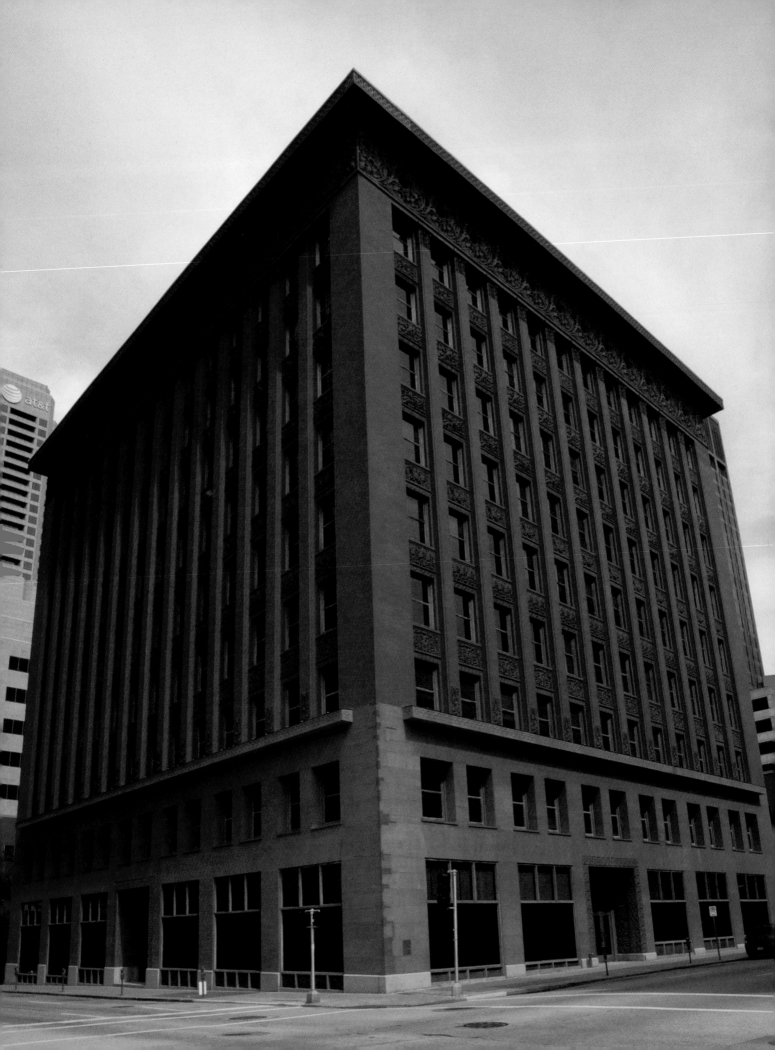

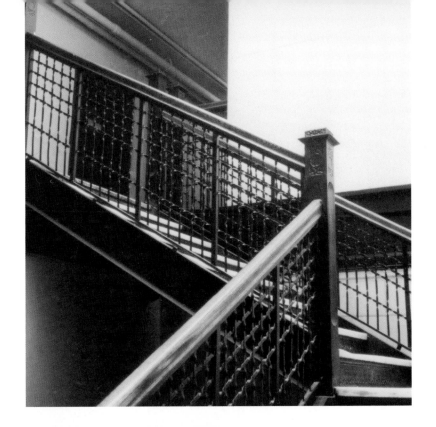

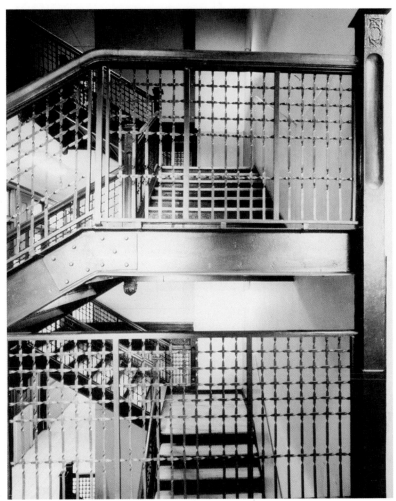

Interior stairwell at the tenth floor (top photo); view from the east hallway and stairwell of seventh floor (bottom photo).

Architect Louis Sullivan (above) claimed to have designed the Wainwright Building in just three minutes. In reality, he built on a decade of discoveries by other architects. The skyscraper was born in the 1880s, when growing American corporations were competing for prime downtown office space in New York and Chicago. As prices increased, real estate developers looked for new ways to pack more office space onto a parcel of land.

To solve the problem architects came up with new technologies, including something called skeleton-frame construction. Instead of needing thick walls of brick and stone to support the structure, architects and engineers found a way to support tall buildings using thin metal frames. This allowed Sullivan to design larger windows for the Wainwright Building, a big selling point in the days before decent electric lighting.

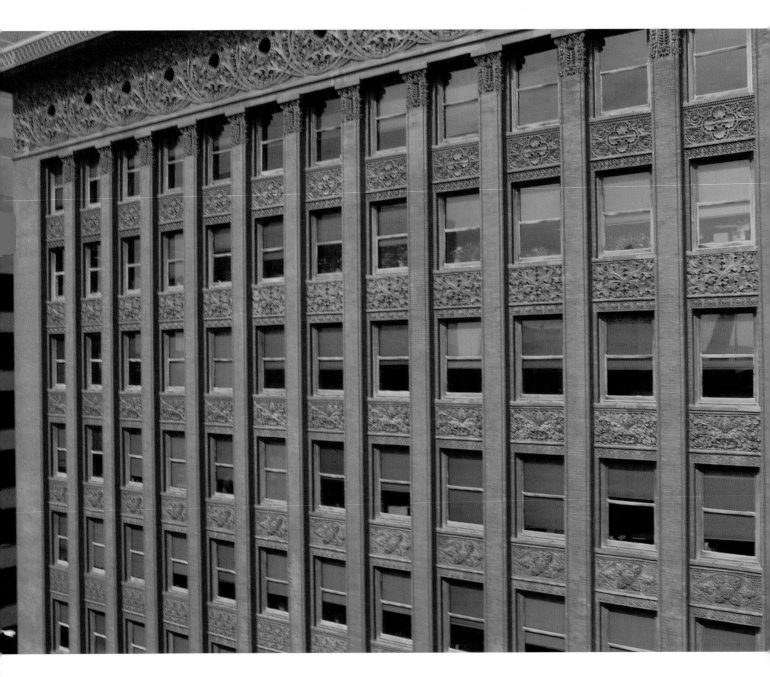

Architects had all of the technology necessary to create tall buildings, including a safe passenger elevator, but they still hadn't really figured out what a skyscraper should look like. Sullivan felt this American invention called for a new approach. The skyscraper, he wrote, "must be every inch a proud and soaring thing."

A lot of tall buildings looked like short buildings just made bigger. Or, in some cases even, two or three short buildings piled on top of each other. —PAUL GOLDBERGER, Architecture Critic, *Vanity Fair*

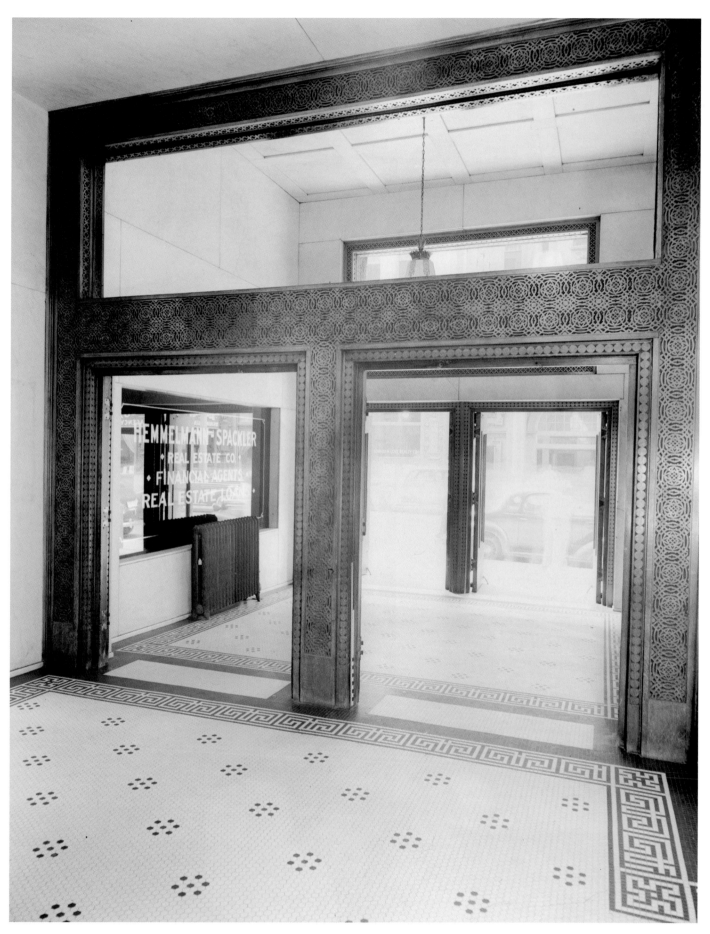

Interior entrance to the Wainwright Building as it appeared in 1940.

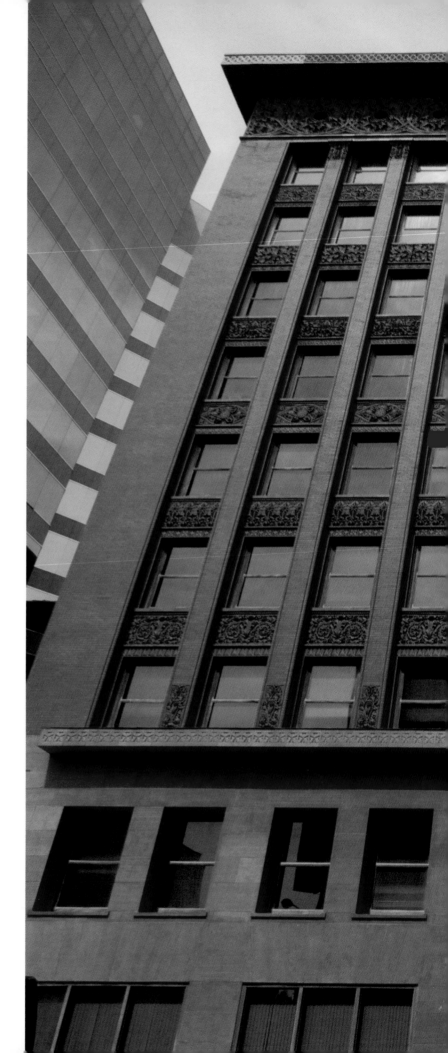

But when Sullivan first sat down to design a skyscraper for beer brewer Ellis Wainwright and his mother Catherine, the architect was reportedly stumped. Unable to envision what his "proud and soaring thing" should look like, Sullivan went for a walk to clear his head. Outside his Chicago offices, an idea for the design came to him. He rushed back inside and famously fired off a sketch in three minutes. He then threw the sketch down on the table of his young draftsman, Frank Lloyd Wright.

Sullivan gave the 10 story Wainwright Building its soaring appearance by using several visual tricks. He started by dividing it into three parts, similar to the "tripartite" design of a Greek column. The first part is the heavy two-story base, which makes the building look solid and gives it a comfortable human scale. Above that, the second part is like the column's shaft. Here Sullivan draws the viewer's eye upward by recessing the horizontal elements, called spandrels, while the vertical piers project without interruption through seven stories of identical office floors. The third, topmost part is like the column's decorative capital, where the building meets the sky.

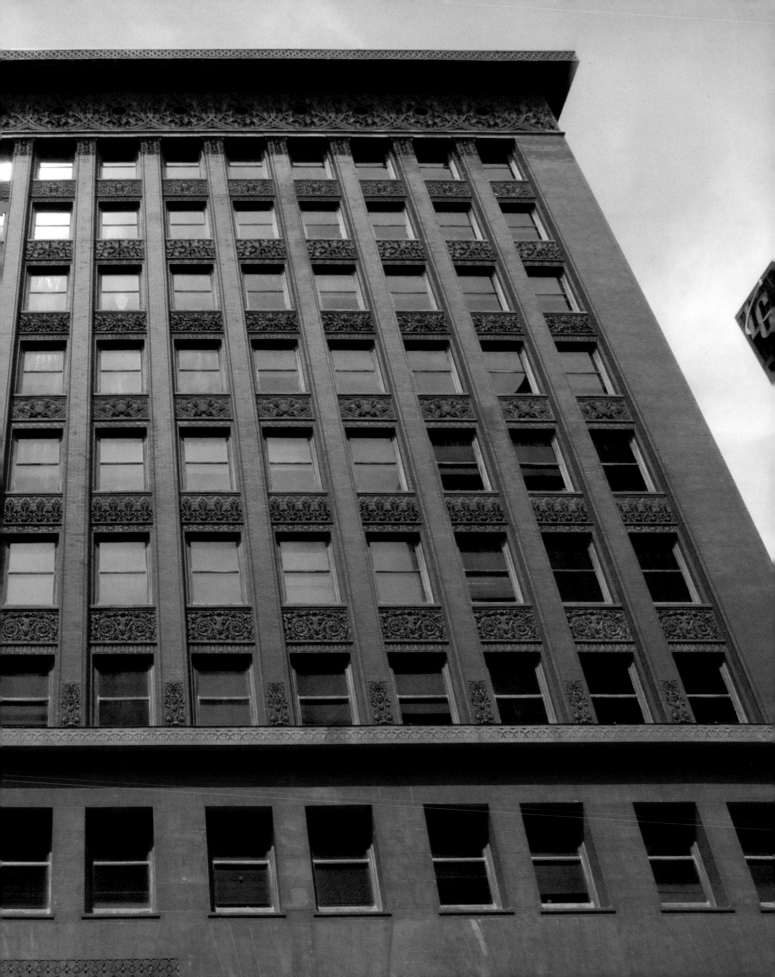

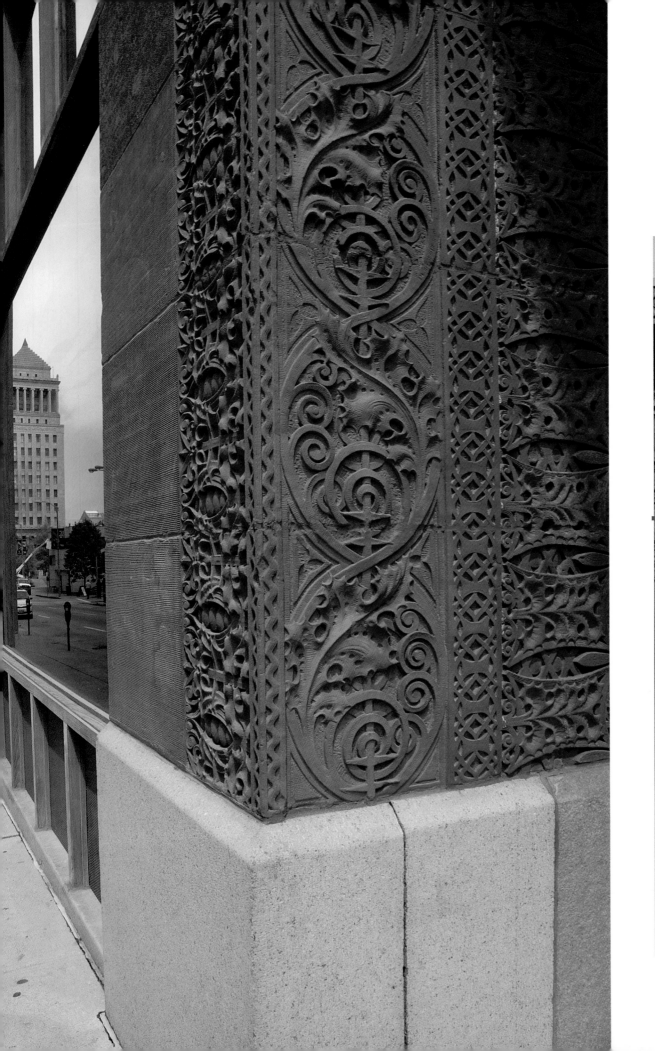
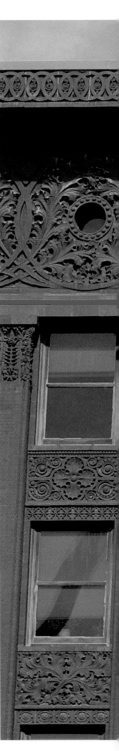

The steel frame is the essence of the building. It's what makes it stand. It's symbolic of the time, symbolic of the technology.

—**TIM SAMUELSON,** Cultural Historian for the City of Chicago

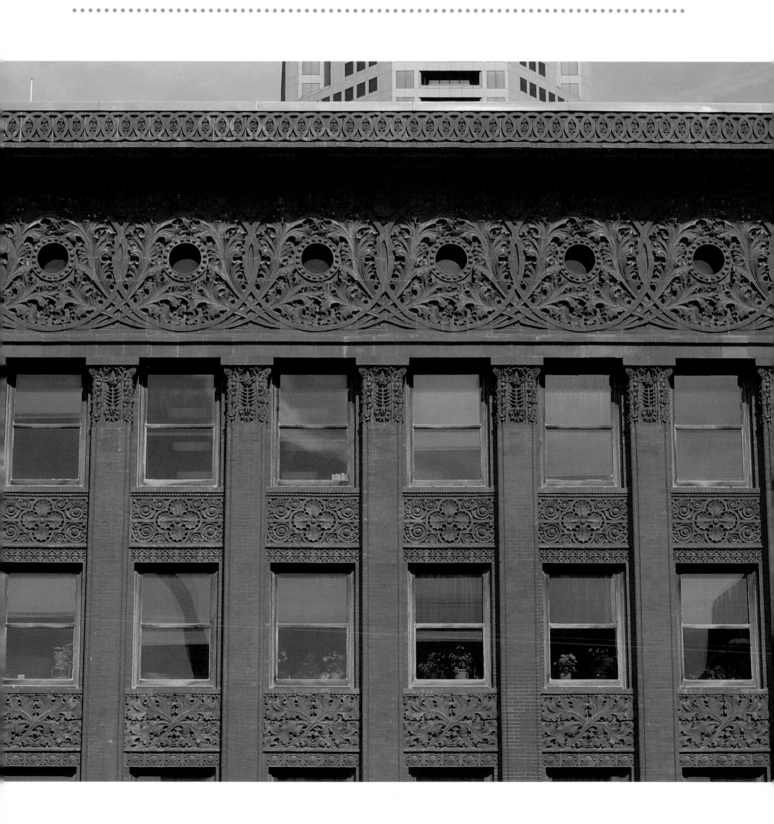

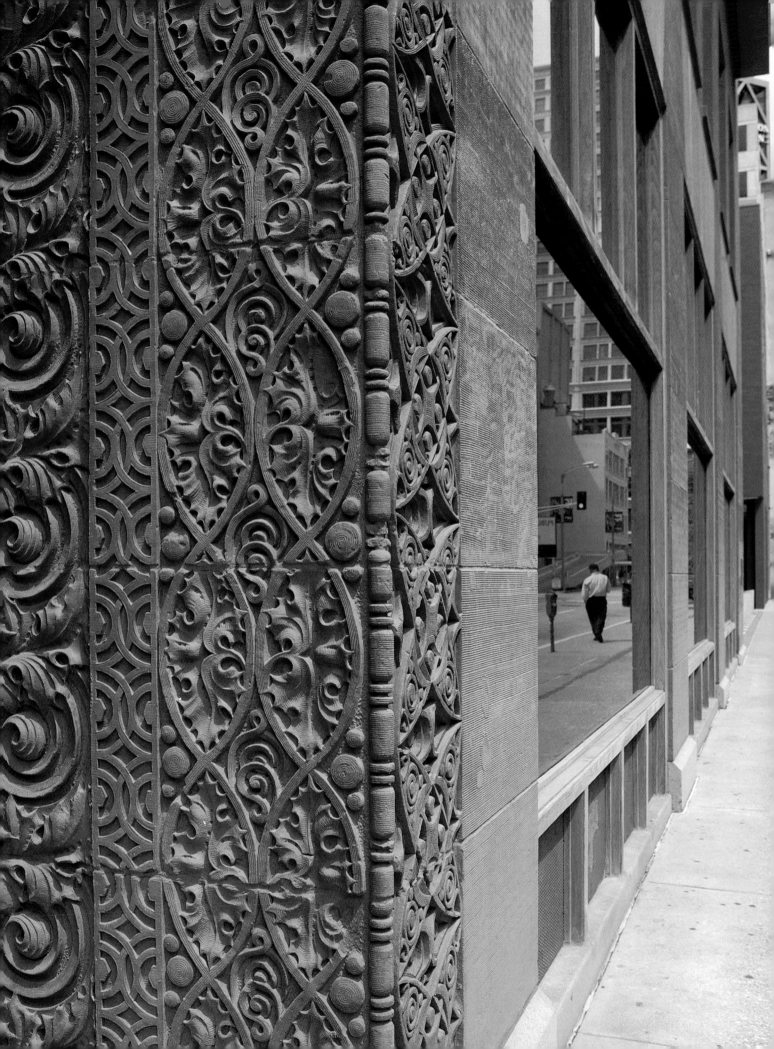

But while the Wainwright's shape is similar to a classical column, the elaborate terra cotta ornament that adorns the building does not feature motifs from ancient Greece and Rome. Instead, Sullivan's trademark flowing shapes were inspired by nature. At the same time, the architect doesn't let us forget the technology that makes skyscrapers possible in the first place. While earlier skyscrapers almost seemed ashamed of their steel frames, the Wainwright Building expresses the grid of its skeleton.

The Wainwright Building set the tone for the next century of skyscraper construction. Skyscrapers would continue to reveal their steel frames and to celebrate their height.

Part of what Sullivan felt was important about the United States of America was the power of the individual[s] to express themselves and create for the benefit of everybody. And if you have each person taking their own talents and their own passions, and bringing buildings vibrantly alive, you are creating an American architecture, but every building is different. It's the power of the individual.

—TIM SAMUELSON

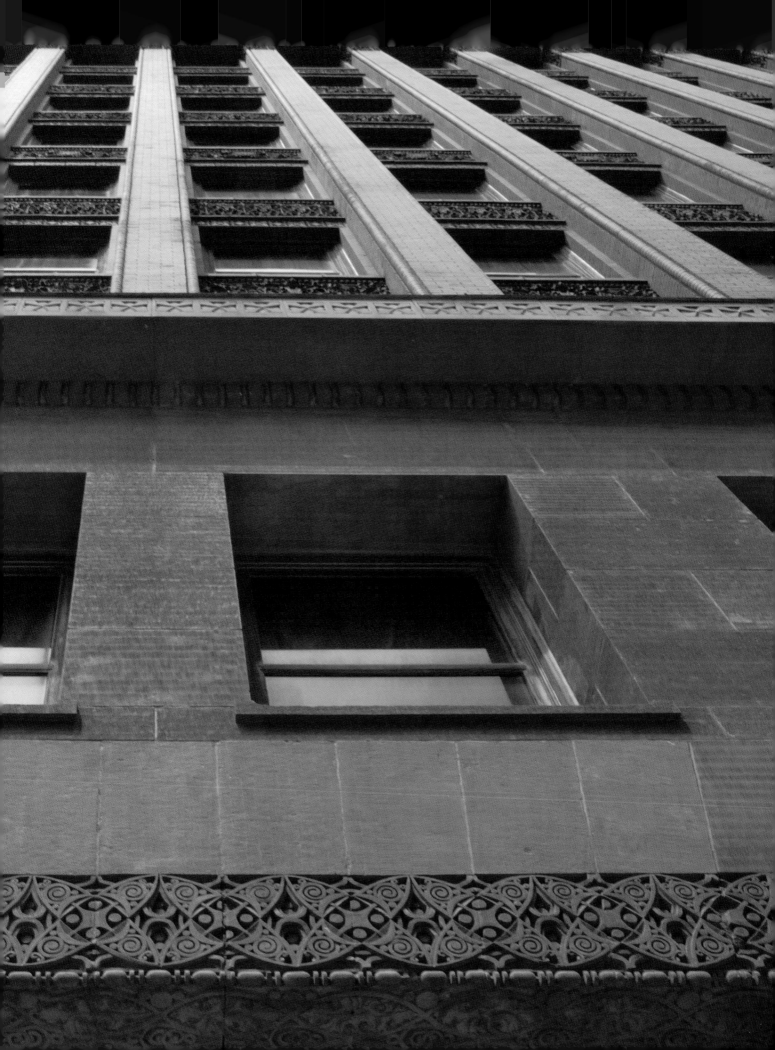

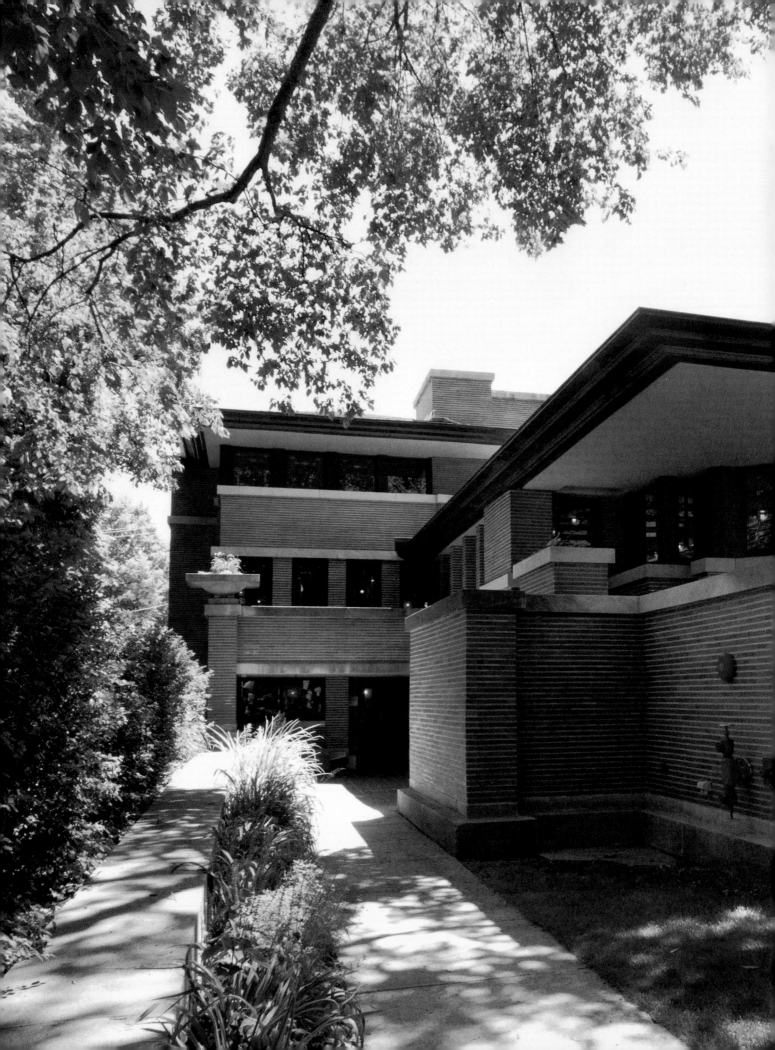

ROBIE HOUSE

- CHICAGO, ILLINOIS
- FRANK LLOYD WRIGHT, 1910

Frank Lloyd Wright once called the Robie House "a source of world-wide architectural inspiration." Humility wasn't one of the architect's strong suits. He freely admitted as much in a 1953 interview with NBC News: "You see, early in life I had to choose between honest arrogance and hypocritical humility. I chose honest arrogance."

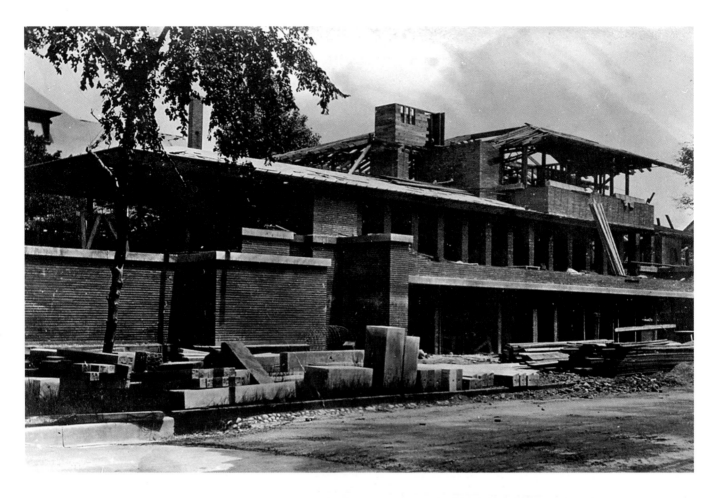

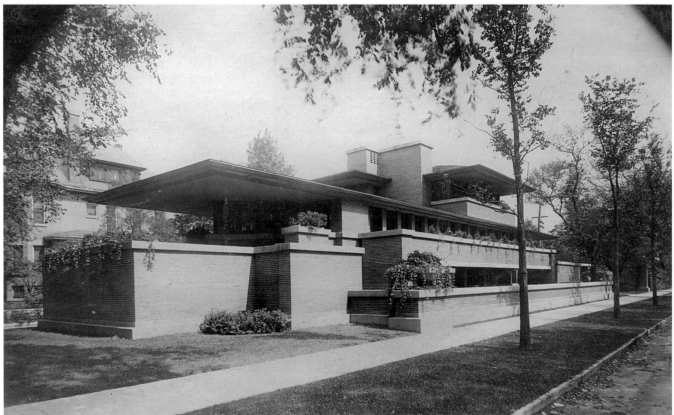

The Robie House under construction (top) and after completion (bottom).

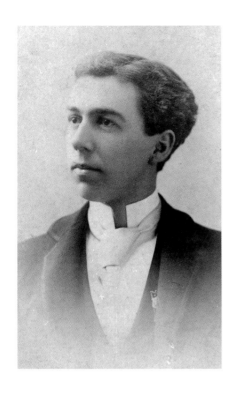

He [Wright] really did feel that America, as this new democratic country...needed a new architectural expression...that was horizontal, open in plan, open across the landscape, a sense somehow that it was connecting to that great open American land.... He saw that American landscape, the openness of it, the sense that it was always moving across the land, pushing westward...and connected to the earth at the same time. All those things you feel in the prairie house. **—PAUL GOLDBERGER**

At the time of its construction, the Robie House was a radical departure from the typical middle-class house, which tended to look like a tall box. Ever since he left his job at Louis Sullivan's office, Wright had been thinking "outside the box" in creating a series of home designs that led up to the Robie House. These became known as "prairie houses" because their earth-hugging designs seemed to belong on the flat lands of the Midwest. As Wright explained, "If the thing is successful...you can't imagine that house anywhere [other] than right where it is. It's a part of its environment, and it graces its environment rather than disgraces it."

These daring homes appealed to clients who weren't afraid to take risks, like Frederick and Lora Robie. Frederick was a 28-year-old bicycle manufacturer who had just ventured into the brave new world of automobile supplies. He and Wright shared a passion for automobiles. As a result, Wright included a three-car attached garage—in 1910!

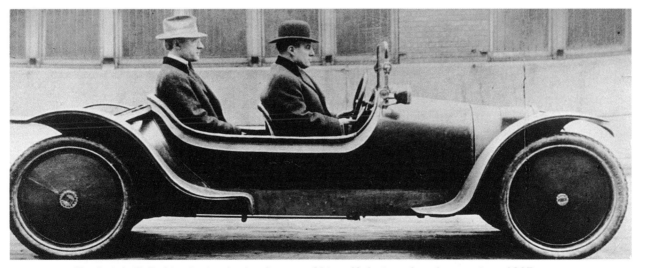

Frederick C. Robie sits in the back seat of his self-designed cycle car, circa 1907.

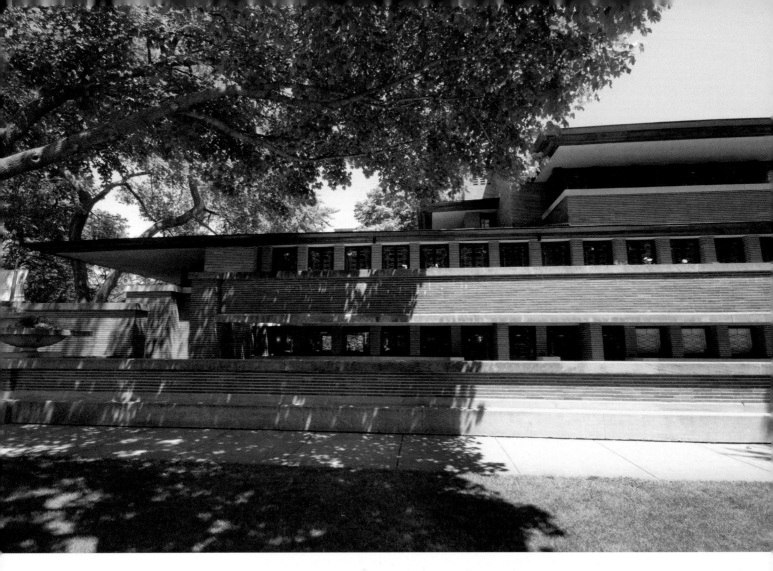

The Robie House isn't located on the prairie but in the city (next page, top), right next to the University of Chicago. Because of the urban context, Frederick was concerned about a lack of privacy. So he asked Wright to design a house that would allow him to see his surroundings from inside the house, without being seen by his neighbors. Wright's solution was to hide the inside with art glass windows (right) and a projecting balcony (above).

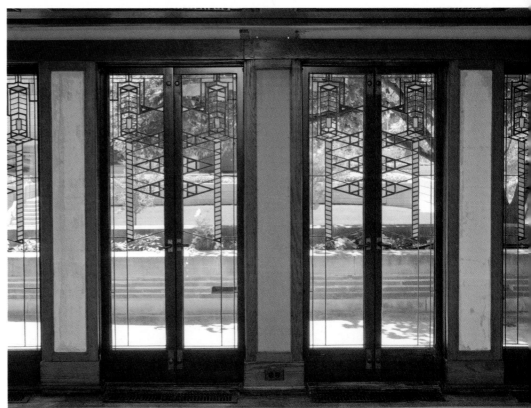

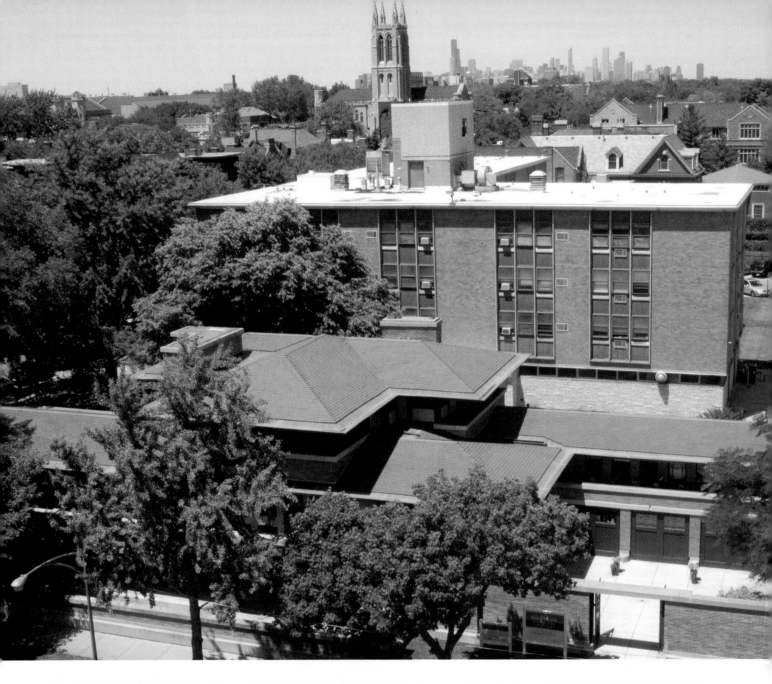

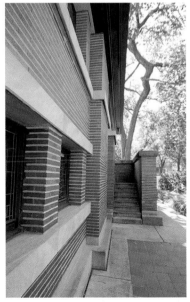

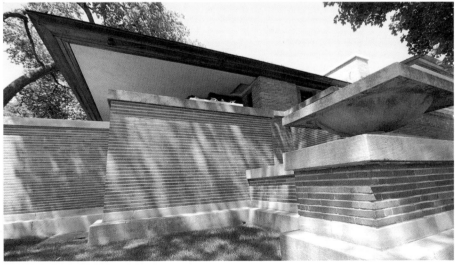

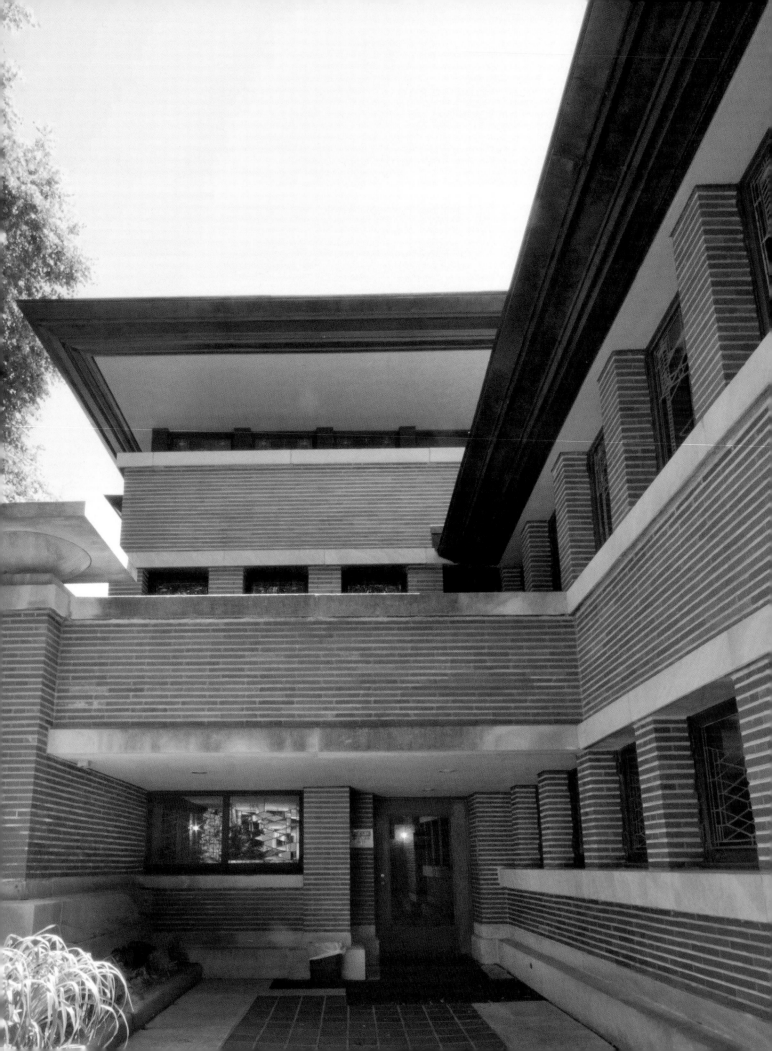

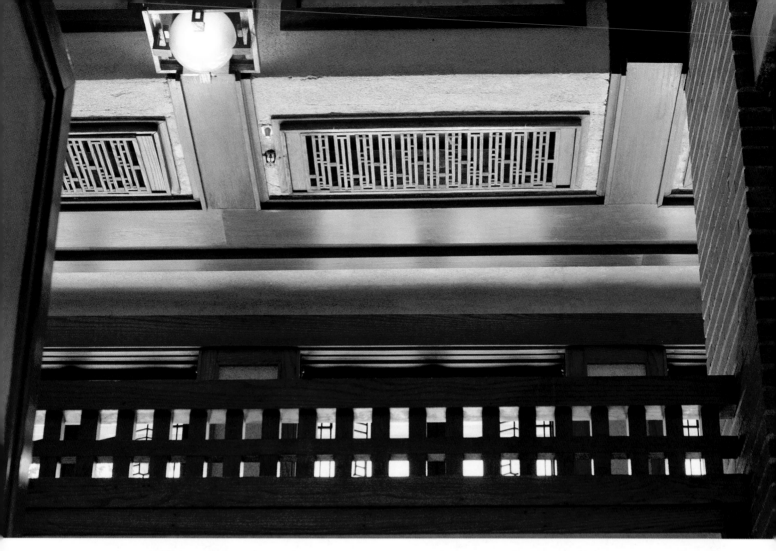

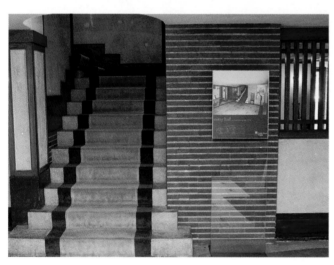

Today the house is open to the public—if they can find the front door. Wright recessed the entrance (opposite page). Just inside the entrance is a dark, confined, reception area that leads to a narrow stairway. Light shines down from the top of the staircase, drawing visitors upward, toward a spectacular, bright space (right and above).

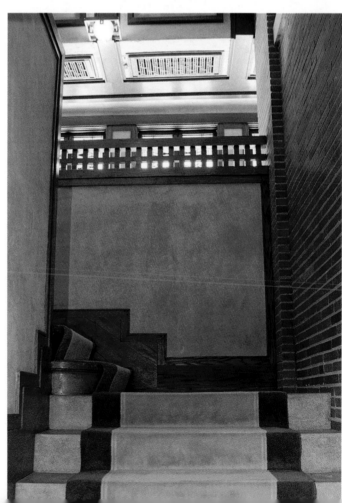

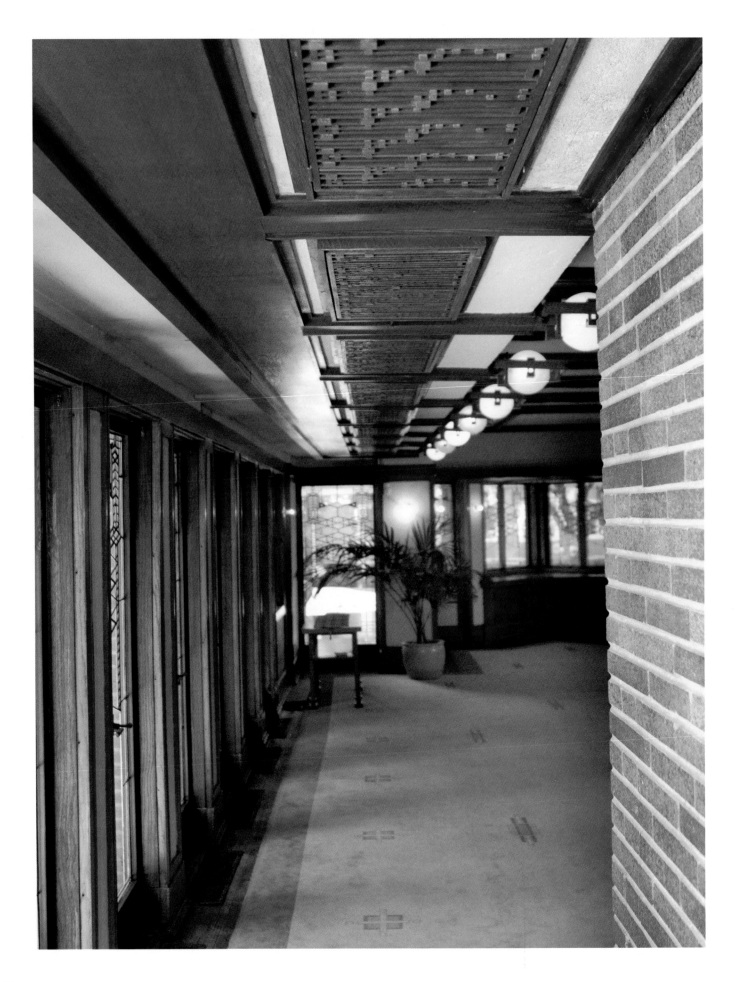

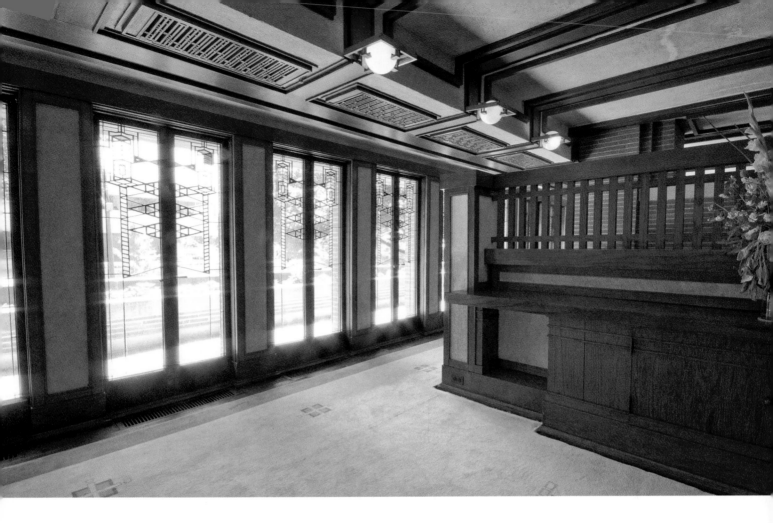

Wright wanted the experience of moving through the house to be a dramatic journey, according to historian Tim Samuelson. It's as though prairie houses guide people through them, appealing to their senses and emotions.

As visitors move through the Robie House, they pass seamlessly from one room into the next, uninterrupted by walls or doors. This revolutionary "open plan" is completely different from the design of typical homes from this period, which were divided into discreet, box-like rooms. This plan catered to the desires of modern American families, whose lifestyles were becoming less formal.

There wasn't a parlor. There wasn't a place for sitting up very correctly and entertaining people.... A lot of American women were asking for houses that were simpler, that were more open, that had a flexible plan. They wanted places that were easy to keep up because they wanted to be able to go and do work outside the home.... They wanted to be able to watch their children while they were doing something else.

—GWENDOLYN WRIGHT
Professor of Architecture at Columbia University and
contributor to the PBS series *History Detectives*

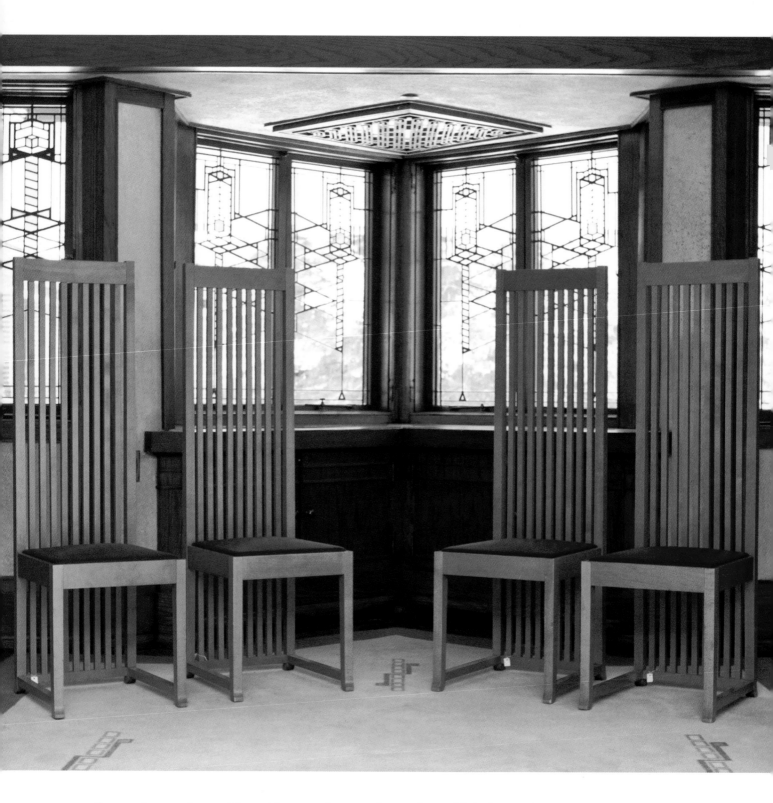

Connections to the world outside were also seamless. Where old-fashioned houses had small windows "punched" into the walls and then covered by drapes, the Robie House has continuous bands of art glass windows.

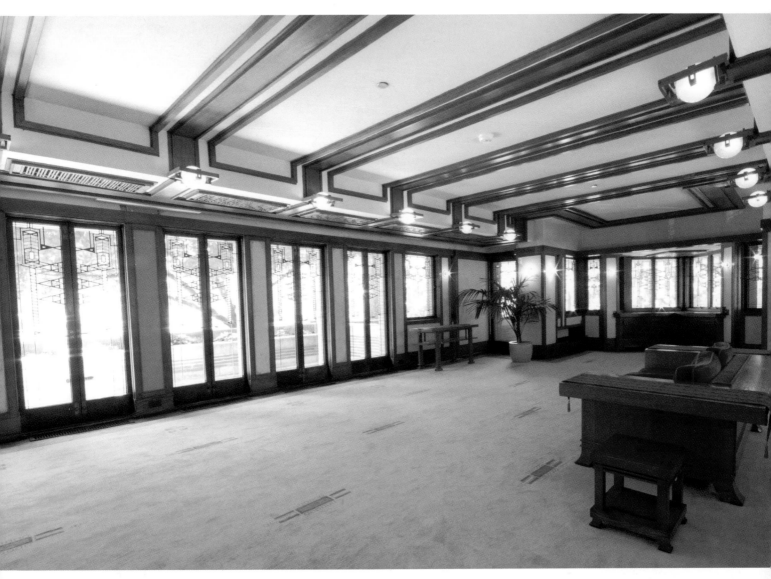

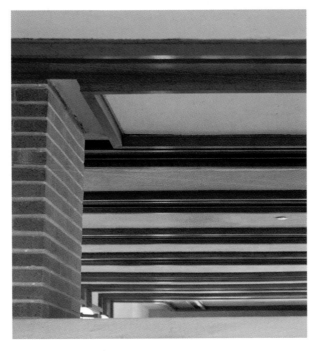

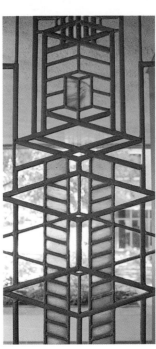

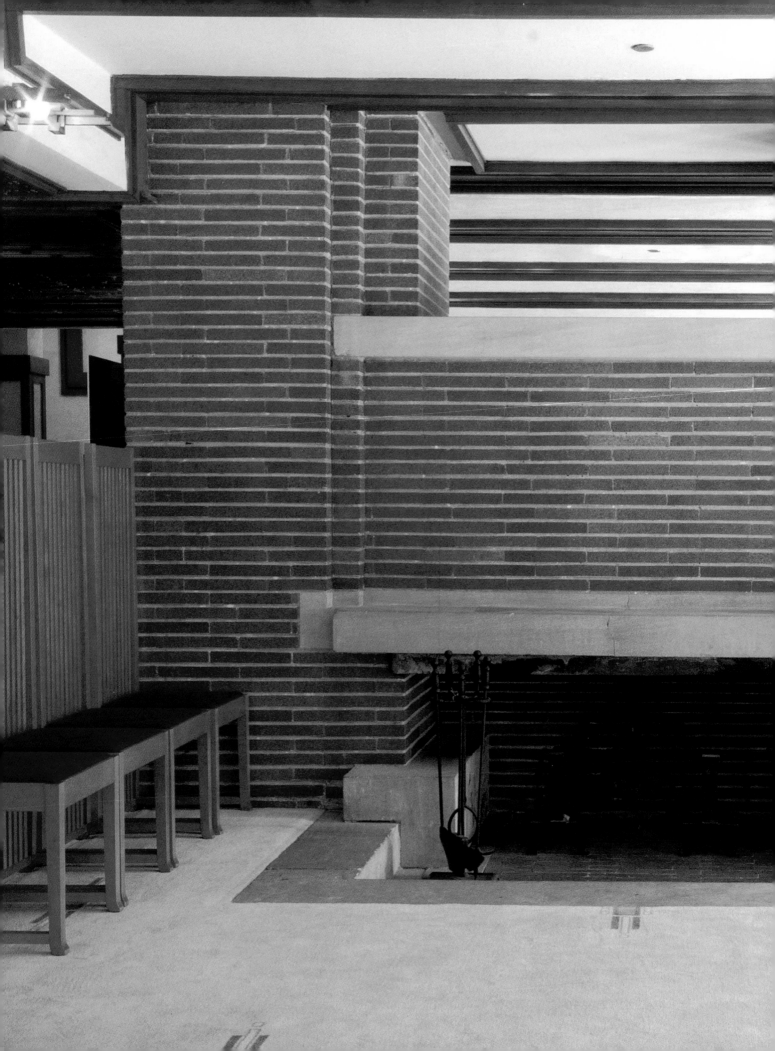

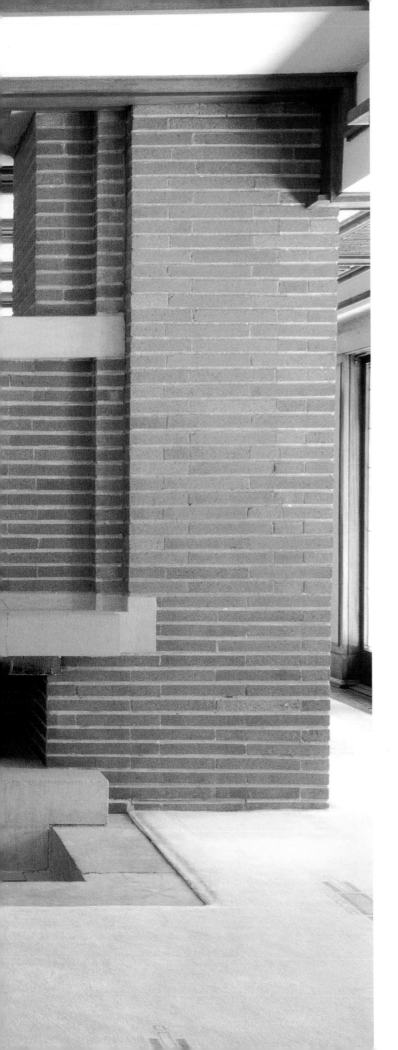

Despite all of its modern features, the Robie House also has a very traditional gathering place: the hearth.

Wright held traditional views about the family and home. But even as his design work reflected his conservative family values, Wright was involved in an affair with the wife of another client. While the Robie House was under construction, Wright and his mistress left their families and fled to Europe.

Wright was not trying to destroy domesticity or comfort. He wanted some aspects of the hearth and... the intimacy of a group of people around. And he builds fireplaces with hearths in every one of the large houses for the rest of his career.... It was this balance of using modern technology, which he's committed to and fascinated by, with the notion of warmth and comfort and well-being.

—GWENDOLYN WRIGHT

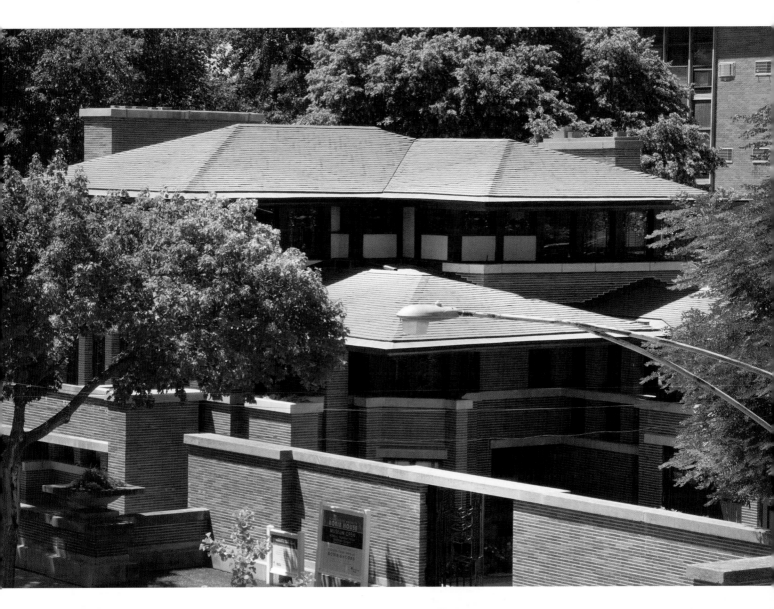

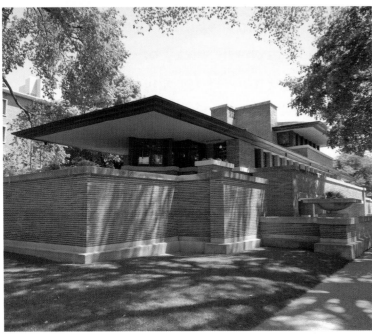

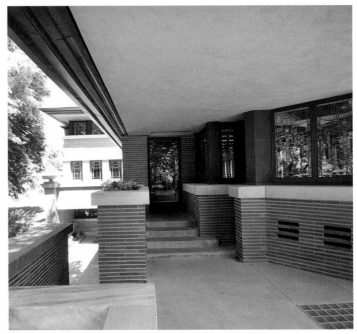

The Robie House wasn't good for Frederick and Lora's marriage either. A year after moving in, Lora and their two kids moved out. The husband and wife split and the house was put up for sale.

Wright visited the Robie House when it was threatened with demolition in 1957. The architect, then 89 years old, had gone on to design some of America's most famous buildings. But he felt compelled to defend this house, which he not so humbly called "a cornerstone of American architecture."

By the late 1950s, it was clear how influential Wright's designs and ideas had become. Builders were cranking out suburban homes that took a page from Wright's book.

"What we would call today the ranch-style house.... Low slung, horizontal, overhanging eaves, low-pitched roofs, and windows gathered together in strips...where have we seen that before?" asks Cranbrook Academy's Reed Kroloff. "Frank Lloyd Wright."

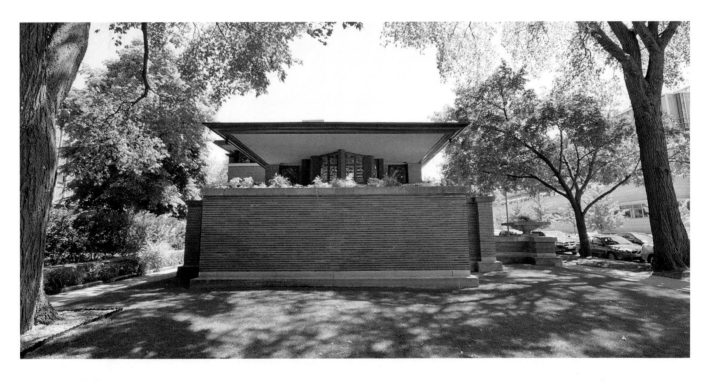

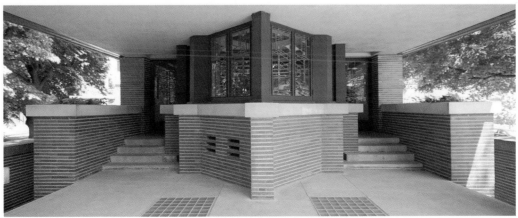

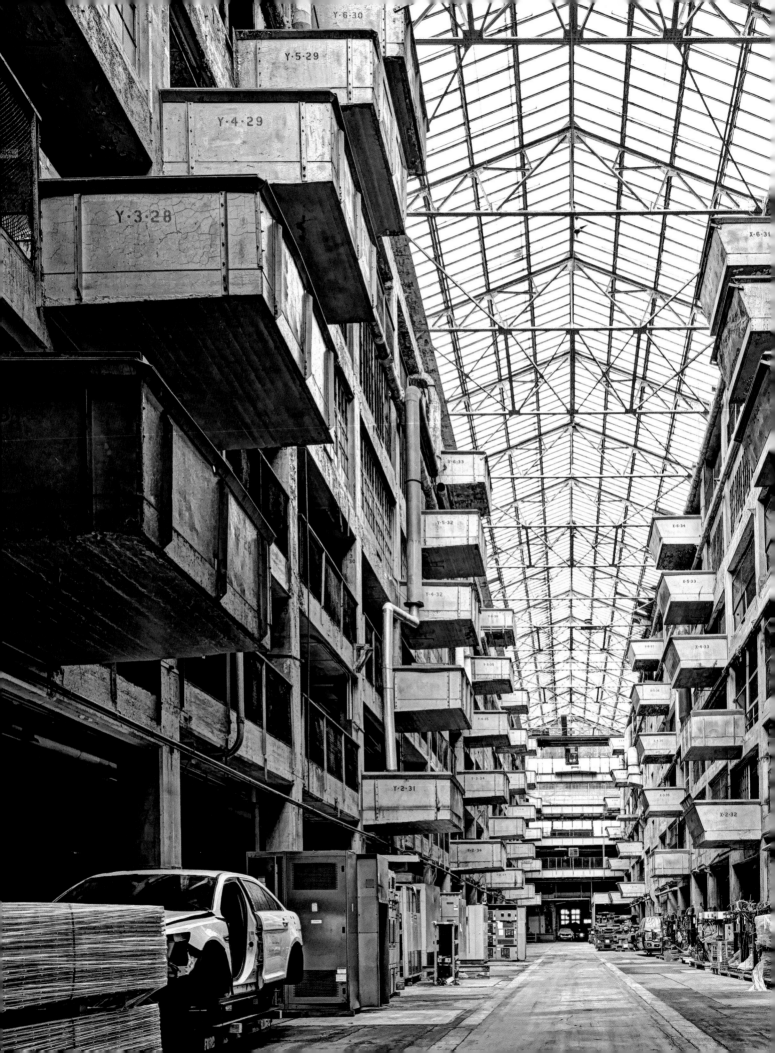

5

HIGHLAND PARK
FORD PLANT

- HIGHLAND PARK, MICHIGAN
- ALBERT KAHN, 1910

When Henry Ford first told architect
Albert Kahn what he wanted him to
design, Kahn thought he was crazy.
Ford said he wanted an entire factory
under one roof with no dividing walls,
and Kahn could not imagine why. Ford
would need the spacious building to
introduce his moving assembly line.

The company's previous plant—the Piquette Plant (above, top)—was typical of the time, with its thick brick walls and narrow windows. The interior space was dimly lit and interrupted by timber posts. This old-fashioned factory was used to build a very modern product: the Model T (above).

The Model T's design was so user-friendly that it allowed just about anyone to drive and maintain the car.

Albert Kahn (top) and Henry Ford (bottom).

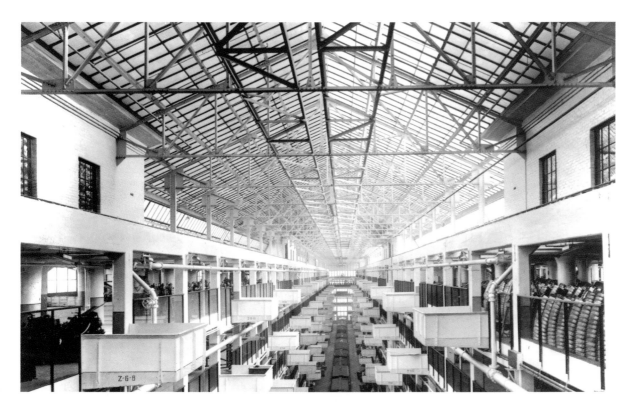

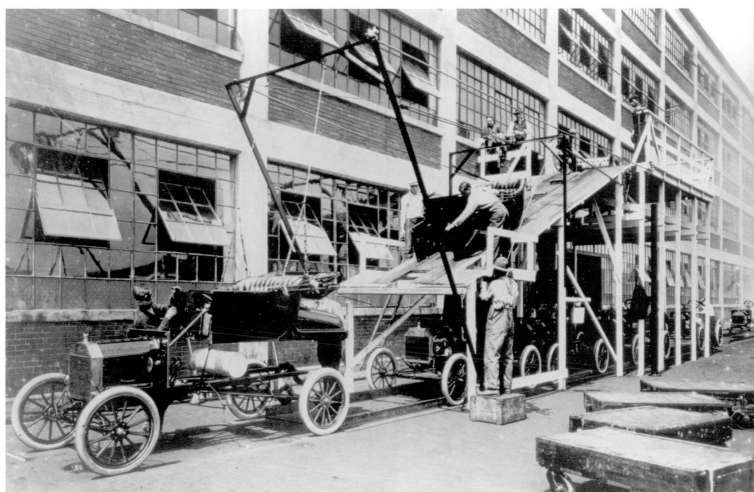

Top photo: Highland Park Plant interior; bottom: the body/chassis assembly line.

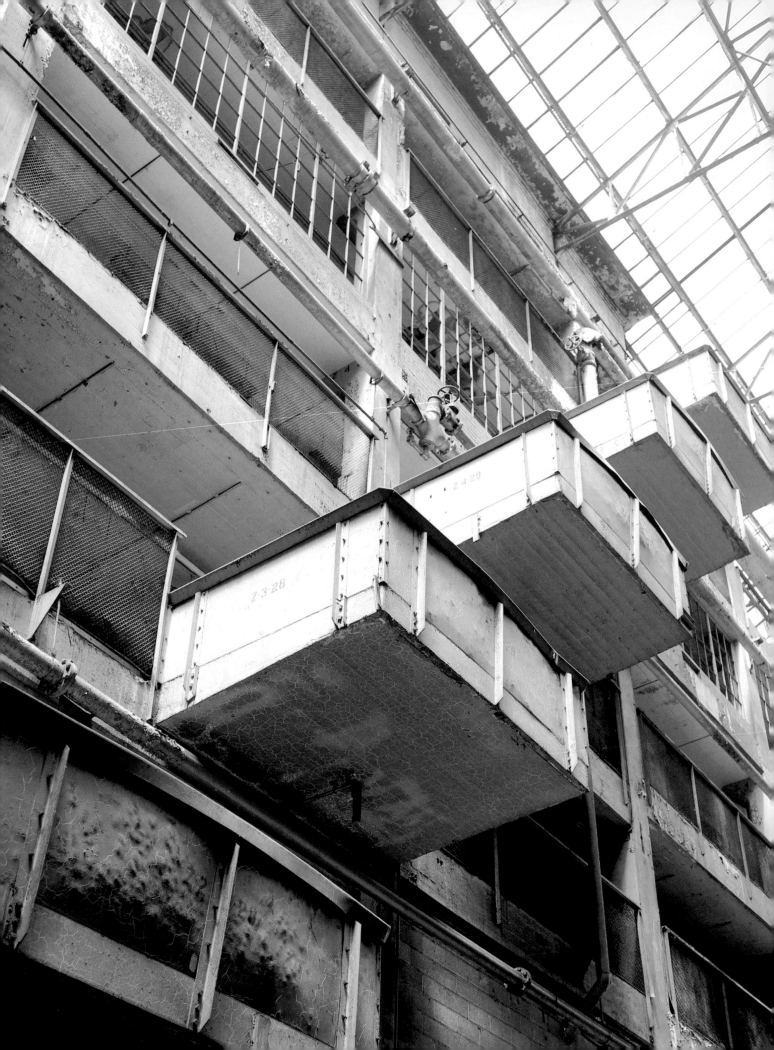

Kahn was not the first one to think that Henry Ford was crazy. Remember, Henry Ford was a visionary and a dreamer, and he saw things that no one else saw.

— **CHARLES K. HYDE**, Professor Emeritus, Wayne State University

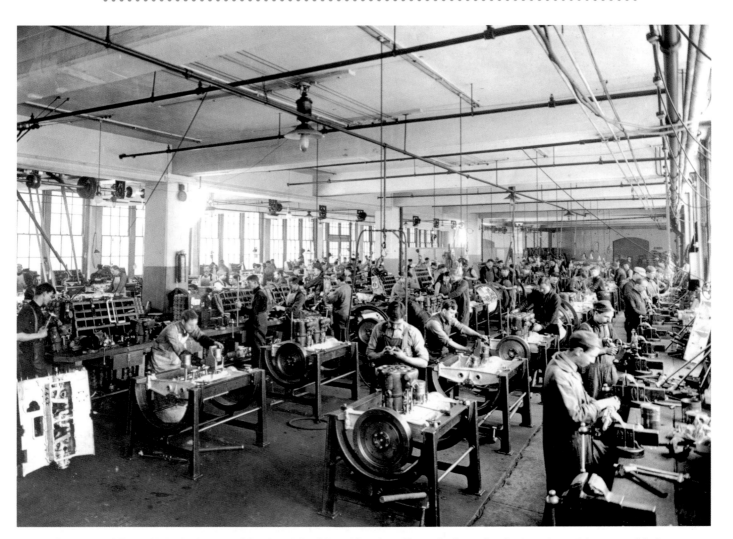

Architect Albert Kahn's design of Packard Building Number 10 made for a bright interior with natural light.

Kahn was the perfect architect to design a new factory for Ford. After all, he had designed the earlier Packard Building Number 10 (above). In 1905, the Packard Building was one of the first "daylight factories," which had huge windows and wide-open floor plans, thanks to their sturdy, reinforced concrete frames. This was what Ford wanted for his new plant (interior of Highland Park Plant on opposite page).

Ford and Kahn made an unlikely pair. Kahn was Jewish and the son of a rabbi. Ford infamously published *The International Jew*, which suggested that Jews were plotting to control the world. Despite their differences, the men teamed up to change the face of American industry in Highland Park, Michigan, just outside Detroit.

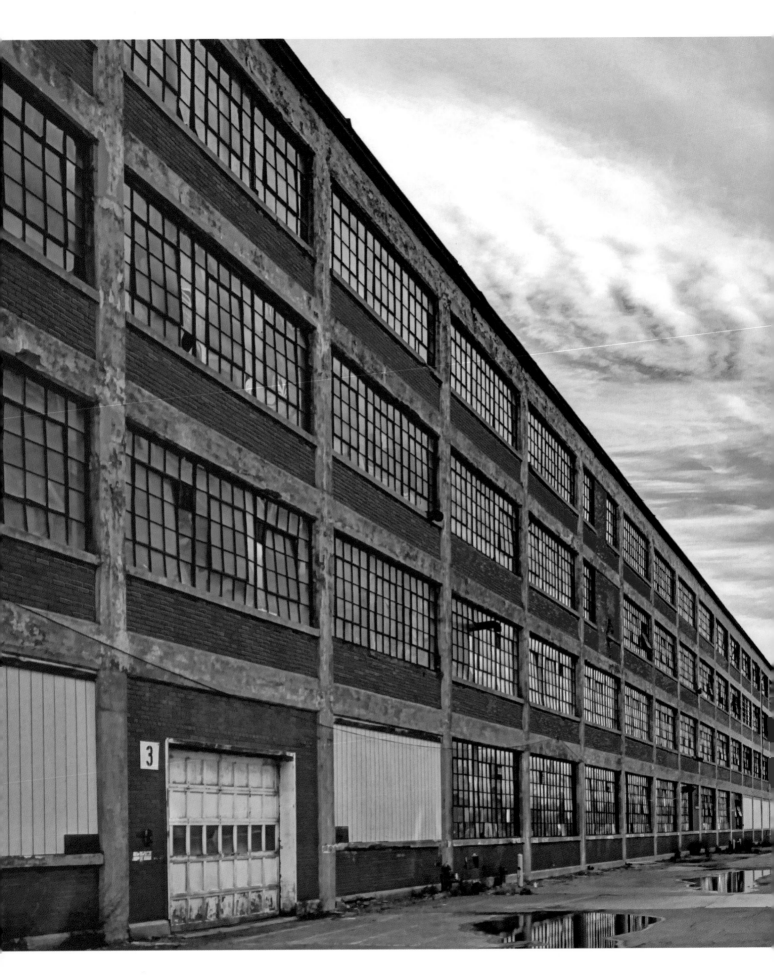

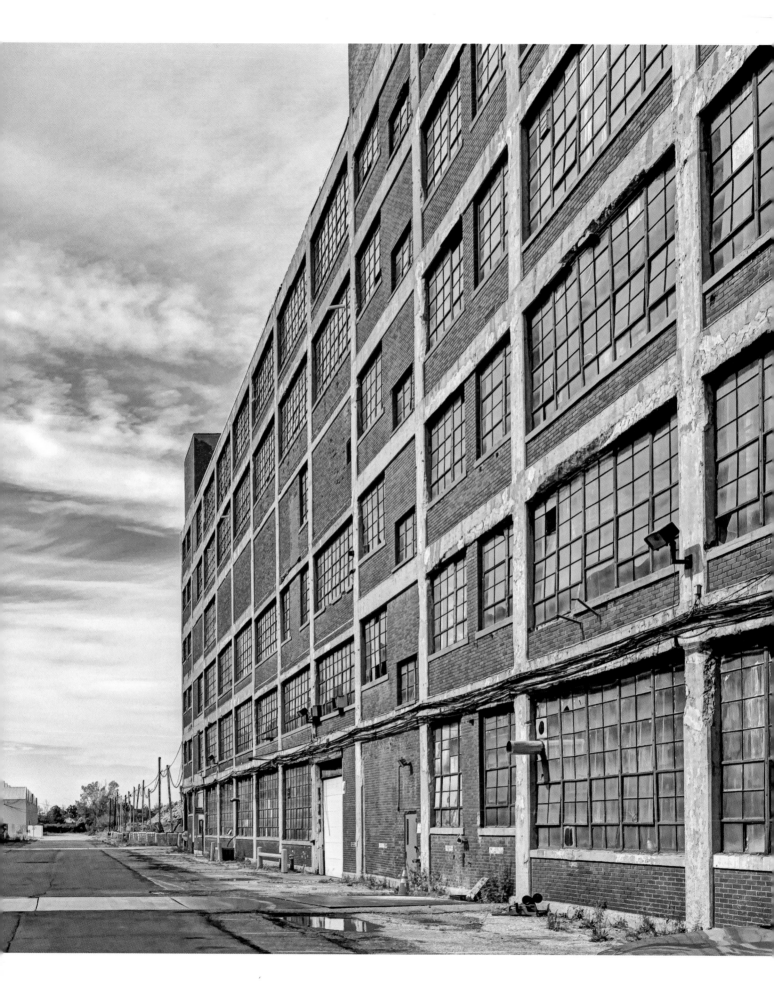

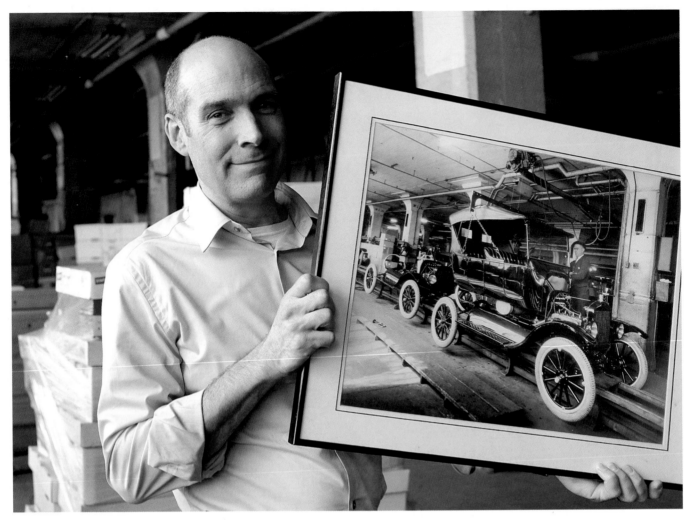

Geoffrey Baer shows a photo of the Model T assembly line that once occupied the section of the plant in which he is standing.

The Highland Park Ford Plant's broad walls of glass supplied light and fresh air to the factory floor. This was good for both the workers and Ford's bottom line. "It improved workers' comfort," says historian Charles K. Hyde, professor emeritus at Wayne State University, "and therefore productivity." The sheer enormity of the complex not only allowed Ford to make most of the Model T all in one place, it also gave the company the space it required to pioneer a new way of building cars.

Before the assembly line, each Model T was constructed on wooden sawhorses by teams of assemblers who moved from one car to the next. Car parts had to be dragged to each car by workers known as "pushers and shovers."

The vast uninterrupted spaces at Highland Park made it possible to move the car through the plant down a long line of workers, each of whom was in charge of performing a single task over and over again. "This saved enormous amounts of wasted motions," says Hyde. "And it brought an enormous reduction in the cost of making Model Ts."

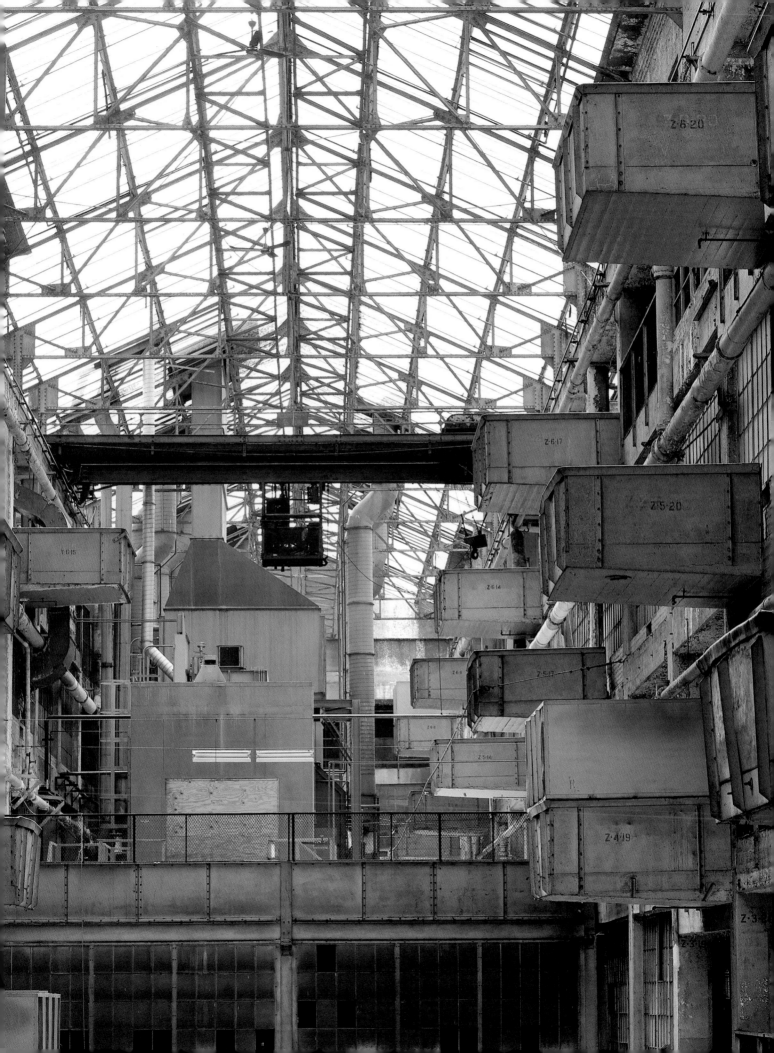

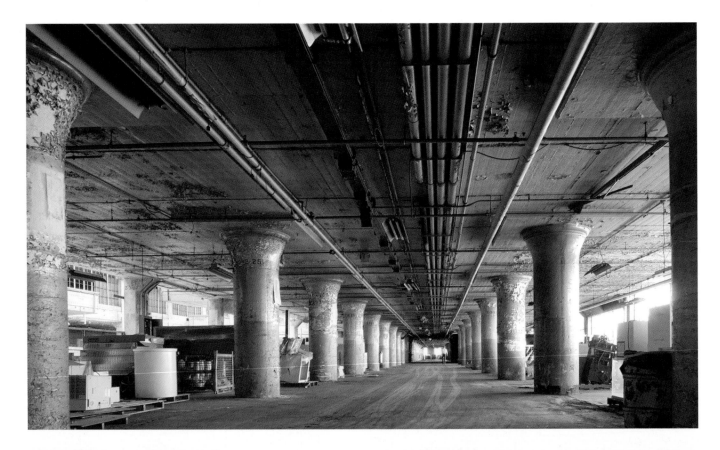

Kahn's plan and execution of the Ford plant set the pattern for American industrial architecture of the 20th century. —TED LANDSMARK

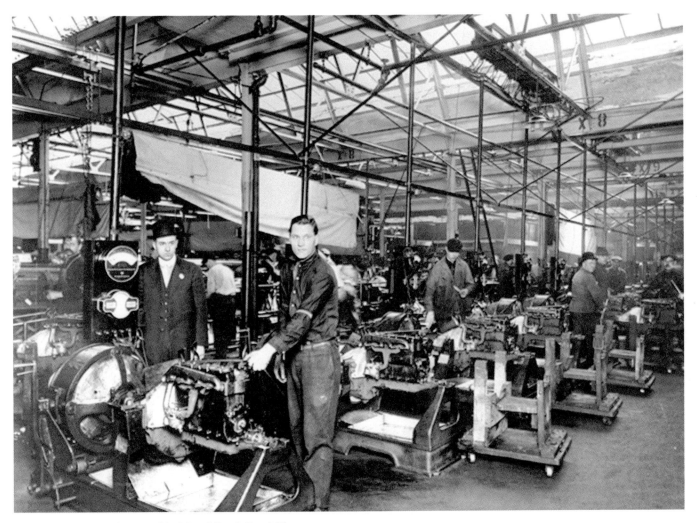

The assembly line at Highland Park Ford Plant.

But Ford still wasn't satisfied with the Highland Park design. He felt that the four-and six-story buildings wasted time and energy moving parts up and down. Just five years after opening Highland Park, Ford asked Kahn to design a new single-story plant called River Rouge.

Over the next 30 years, as Ford continued to improve his production processes, he called on Kahn to design more than 1,000 factory buildings. In fact, Kahn worked on so many plants that he had to turn his office into a virtual assembly line for architecture. He doled out repetitive tasks to an army of designers, draftsmen, and engineers as they worked on building after building. Like Highland Park, and every American factory that came after it, these factories would have wide-open spaces that were filled with light.

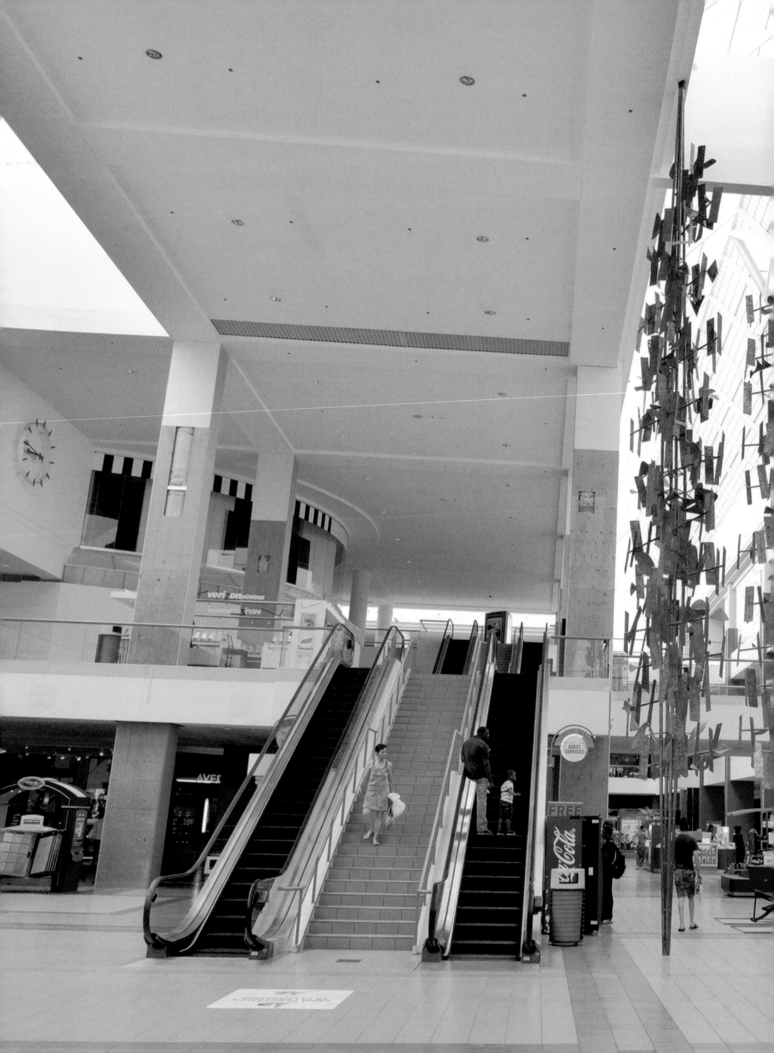

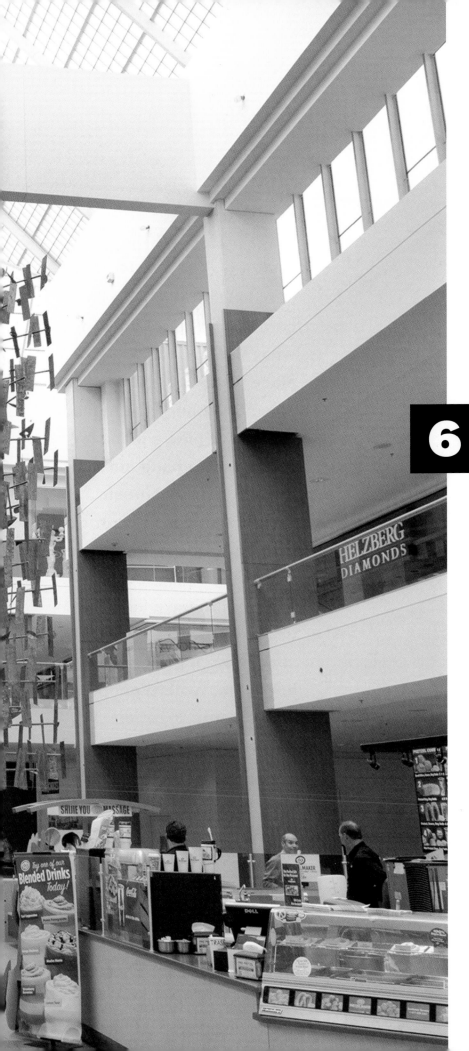

6

SOUTHDALE CENTER

- EDINA, MINNESOTA
- VICTOR GRUEN, 1956

Architect Victor Gruen was a socialist who invented something which, at first glance, would seem to fly in the face of his politics: the regional indoor shopping mall. But as Gruen envisioned it, Southdale Center in Edina, Minnesota, was more than a mall. It was a vibrant community space inspired by the bustling street life of Vienna, Austria, where Gruen grew up.

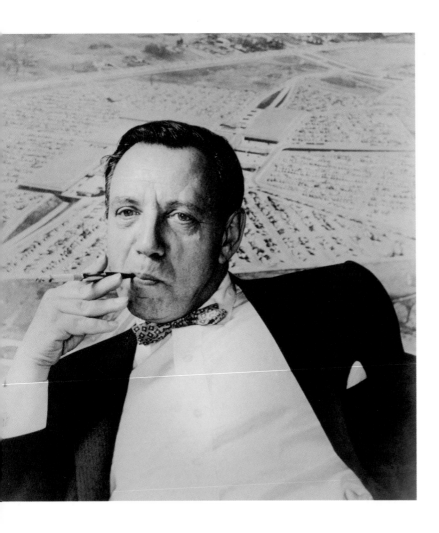

He [Gruen] wanted to make places to bring people together…. In the 1950s people wanted places to come together, and partly what Gruen provided at a place like Southdale was a place to sit and chat, a place for kids to play, a place for teenagers to hang out, a place to enjoy yourself…. So he's doing it to promote consumerism, but his heart was really in the idea of trying to make a kind of urban culture that he had seen himself growing up in Vienna…where people would come together and talk.

— GWENDOLYN WRIGHT

Gruen (above) studied architecture at the Vienna Academy of Fine Arts, the same school that had rejected an aspiring artist named Adolf Hitler ten years earlier. When Hitler's pursuits turned more sinister, Gruen, who was Jewish, fled to America.

Gruen made a name for himself designing dazzling storefronts on New York's Fifth Avenue. But he recognized that the retail action in post–World War II America was shifting to the suburbs, and he didn't like what he saw. He was dismayed by the unsightly commercial strips that sprawled for miles on end, which he referred to as "the greatest collection of vulgarity…ever collected by mankind."

He got his chance to make his mark on suburbia in 1952, when the Dayton Company hired him to design a shopping center in Edina, a Minneapolis suburb. But Minnesota, with its bitter winters, wasn't well-suited to the standard outdoor shopping center.

He wanted to get people out of their cars…. He was worried that everyone would go from their private house, to their private car, to their private office and back, and never get to know their neighbors, never have any interaction…. So that was the idea of the mall.

— TOM FISHER
Professor and Dean of the College of Design, University of Minnesota

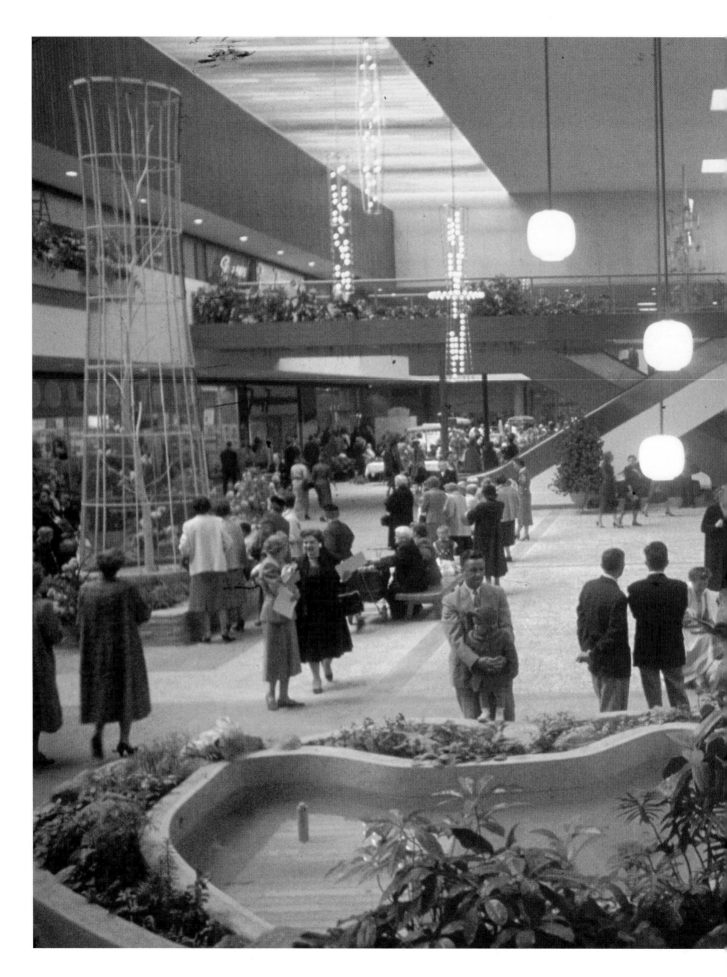

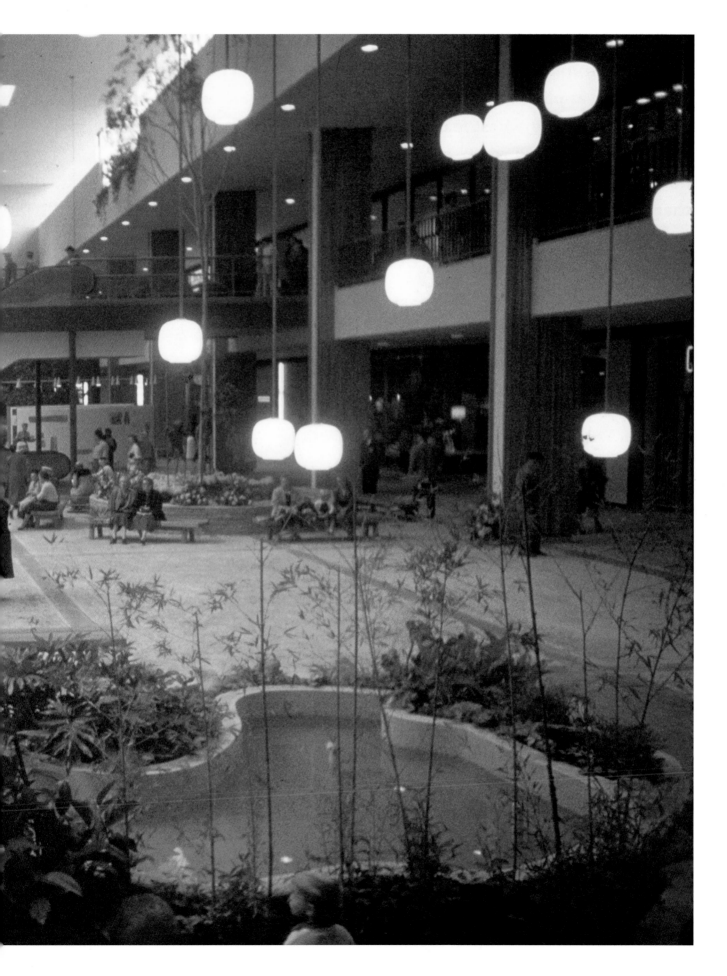

This was really conceived of as a town center…. He really envisioned these as community centers that had shopping as part of them rather than as places that you simply go to shop…. He wanted to bring some of the best features of downtowns out to the suburbs in the form of a mall where people could be walking…. Suburbs needed the equivalent of a downtown, and [Gruen] was concerned that they weren't building [these areas]…. The mall interior should have about the same dimension as the urban streets. —TOM FISHER

Small neighborhood shopping centers had been enclosed before. But Southdale is where Gruen introduced the formula for the regional indoor mall, a concept that might have seemed puzzling to shoppers driving up to Southdale for the first time. The idea was to take the typical suburban shopping center, which faced out to the street, and alter it so that the stores faced inward, toward a central, air-conditioned space. This way, all of the sprawling commercial clutter he hated would be hidden in a contained facility with a plain exterior. Gruen called this arrangement "the introverted type."

Inside, Southdale was a shopper's paradise—72 stores under one roof. But this wasn't just a place to buy things. At its center was the "Garden Court of Perpetual Spring," which featured a goldfish pond, an aviary, sculptures, and a "sidewalk" café. There was even a small zoo in the basement. Suburbanites could get out of their cars and enjoy all of the benefits of a downtown shopping district without the traffic and dirt.

The urban-like setting of Southdale was also good for business. Because the experience was so dazzling and fun, customers stayed longer and shopped more. The windows were placed high overhead, so that shoppers wouldn't be distracted by what was going on in the outside world.

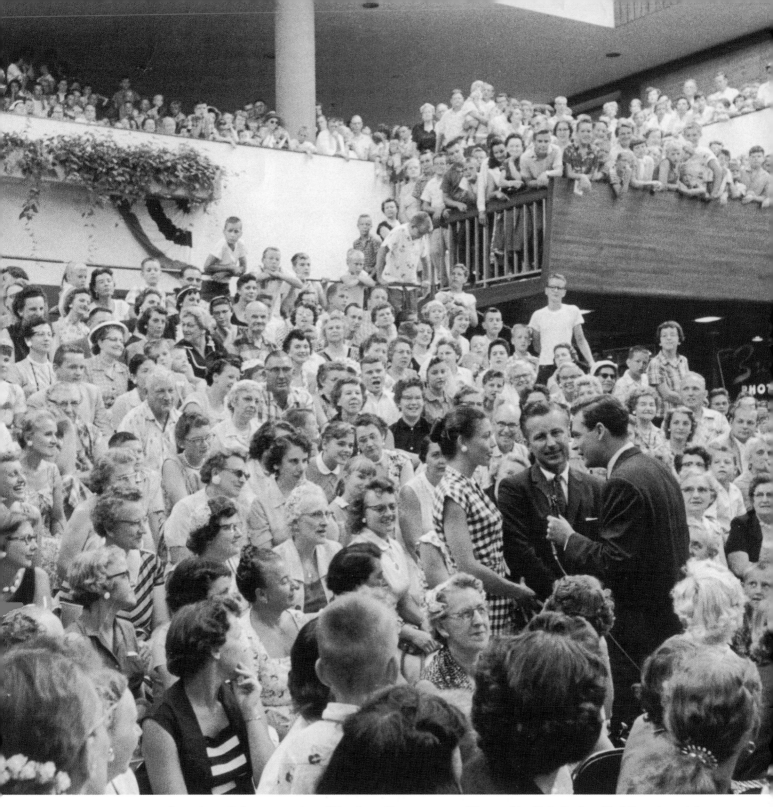

A taping of the game show "Truth or Consequences" hosted by Bob Barker (holding the mic) at Southdale Center in the late 1950s.

The socialist architect had created a capitalist cash cow. On the day Southdale opened in 1956, 75,000 curiosity-seekers came out to see what *Life* magazine dubbed "The Splashiest Shopping Center in the U.S." It did have at least one detractor. Frank Lloyd Wright took a tour and said that the garden court had "all the evils of the village street and none of its charm.... You have tried to bring downtown out here. You should have left downtown downtown."

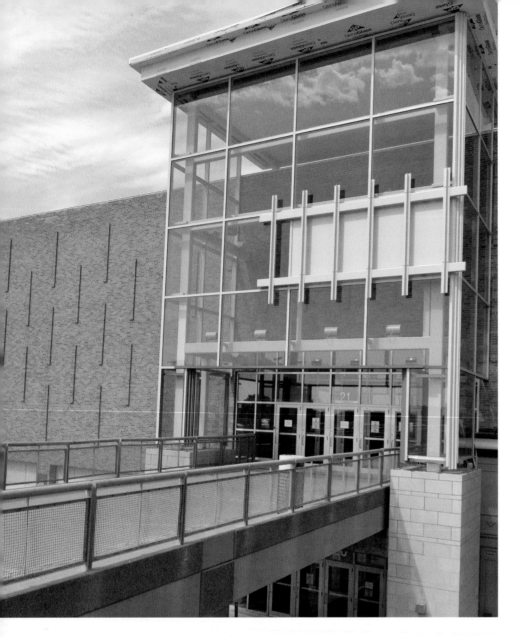

Over time, Gruen himself grew disillusioned with his grand experiment. He had envisioned the shopping center as one piece of a larger planned community that was supposed to include houses, apartments, offices, and schools. He had hoped this would be a compact and well-ordered alternative to sprawl and blight, but most of his vision was never realized.

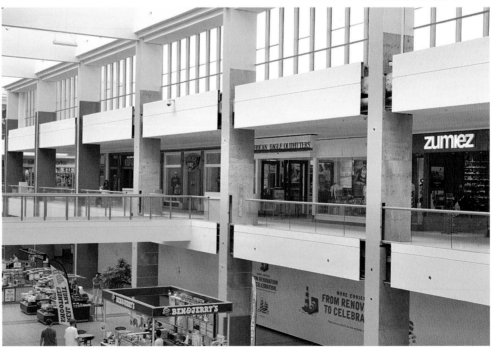

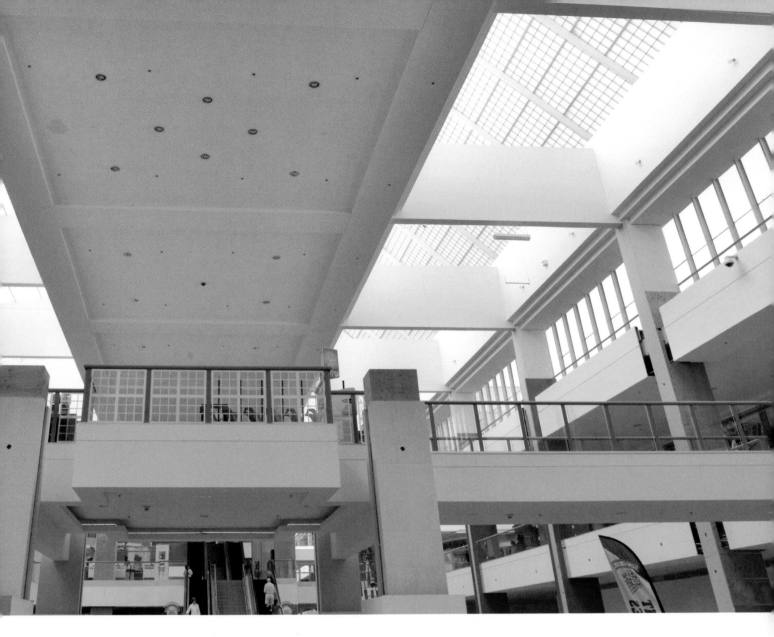

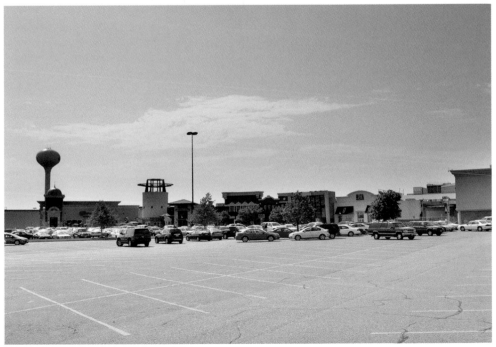

Instead, Southdale became an isolated island of retail in a sea of parking (left). And that is what large swaths of suburban America came to look like, as the indoor mall concept was imitated far and wide. Gruen called these copycat malls "bastard developments" because they lacked his larger social vision and attracted more of the sprawl he had tried so desperately to fight.

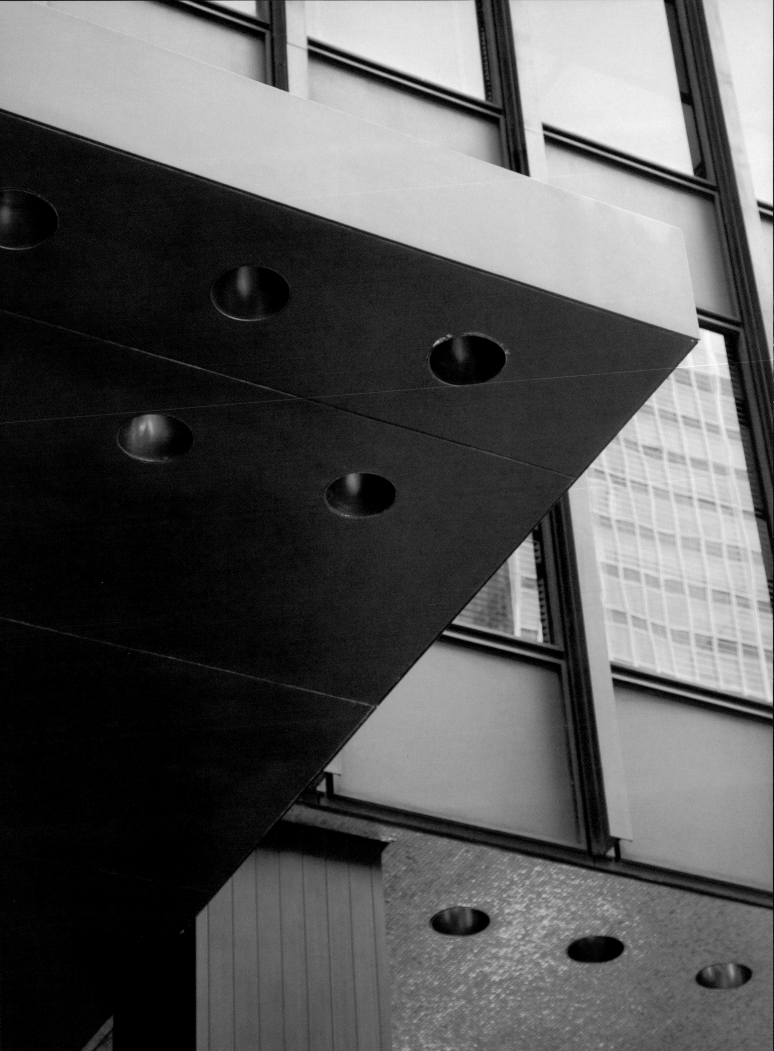

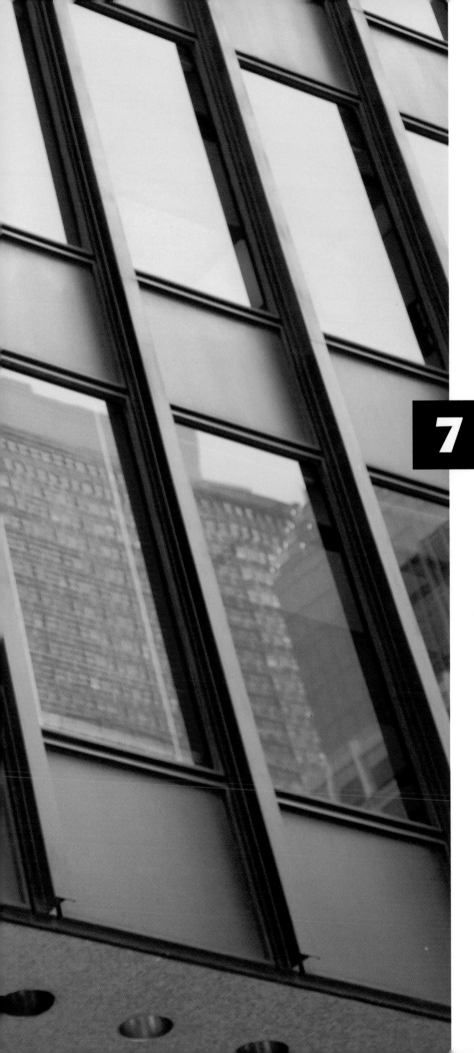

SEAGRAM
BUILDING

■ NEW YORK, NEW YORK
■ LUDWIG MIES VAN DER ROHE, 1958

The sleek glass Seagram Building in
Midtown Manhattan has been so
widely imitated that today it looks
almost ordinary. But when it was
completed in 1958 it was ground-
breaking. It was commissioned by
the Seagram Company to serve as
its U.S. headquarters. The corporate
giant ended up with such an avant-
garde structure because a young art
student, Phyllis Lambert, chose
the architect.

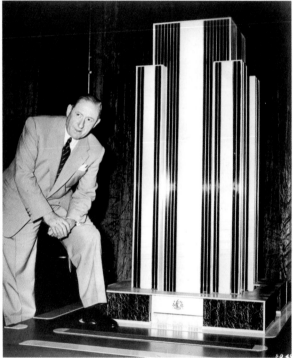

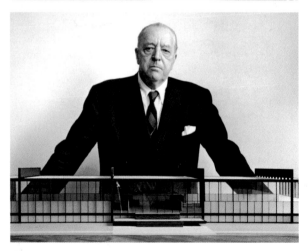

Lambert (left, top photo, with Geoffrey Baer), who was just 27 at the time, learned that her father, Seagram president Samuel Bronfman, planned to erect the company's headquarters on New York's posh Park Avenue. But Lambert was more interested in the building's aesthetics than its intended use. In her words, "To me, it wasn't a corporate headquarters; it was a skyscraper in New York." She was appalled when she saw the original design by architect Charles Luckman (left, middle photo). She pleaded with her father to consider something else. "I wrote my father a long, long...letter," she said. "And the letter starts off, 'No. No. No.'"

The original design would have looked right at home in pre–World War II America, but Lambert understood that the country had entered a new architectural age. Architects were starting to build skyscrapers without all of the bricks and stone and decoration that had covered steel frame buildings since Louis Sullivan's time. Instead, modern designers were letting naked steel and transparent glass speak for themselves.

Bronfman was convinced by his daughter's letter. He named her director of planning for the building, and she set out across the country to find the right architect. Lambert met with some of the great designers of the day—most of whom compared themselves to the German-born architect Ludwig Mies van der Rohe (known simply as Mies) (left, bottom photo). Lambert understood why when she met Mies himself. "There was a kind of presence about that man," Lambert said. But it wasn't Mies's personality that sold her. It was his work.

Top photo: Geoffrey Baer and Phyllis Lambert; middle photo: original design model with Seagram executive Victor A. Fischel; bottom photo: Mies van der Rohe with an architecural model of Crown Hall in Chicago.

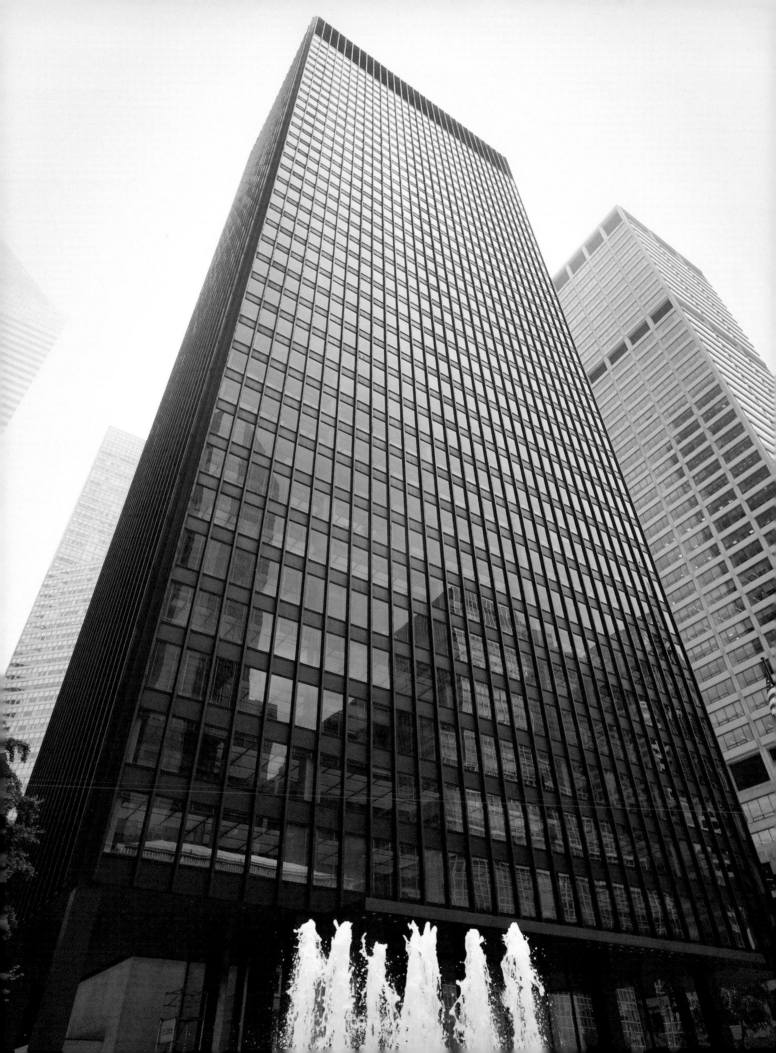

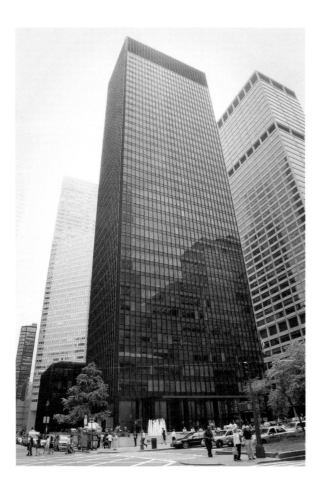

Way back in the early 1920s, long before he moved to America, Mies had envisioned building glass skyscrapers in Germany. He was part of a generation of European modernist architects who used the latest technology to confront the war and inequity that plagued the continent.

According to architectural historian Barry Lewis, "You know, they came out of World War I...and they understood what caused World War I, this intense, insane nationalism.... And Mies van der Rohe and his gang...wanted to create a new architectural language, a kind of United Nations of an architectural language that everybody could understand."

This "international style" became popular with corporate America after World War II for less idealistic reasons. It made a company look cutting-edge and efficient. Plus, it could be inexpensive.

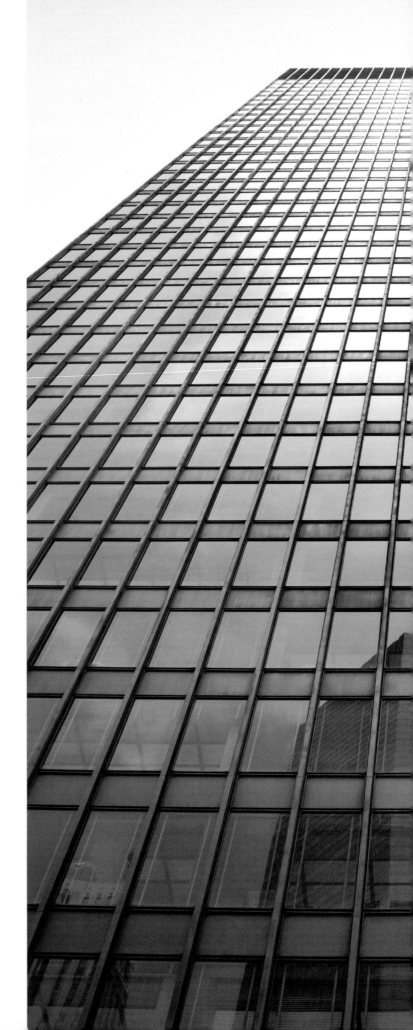

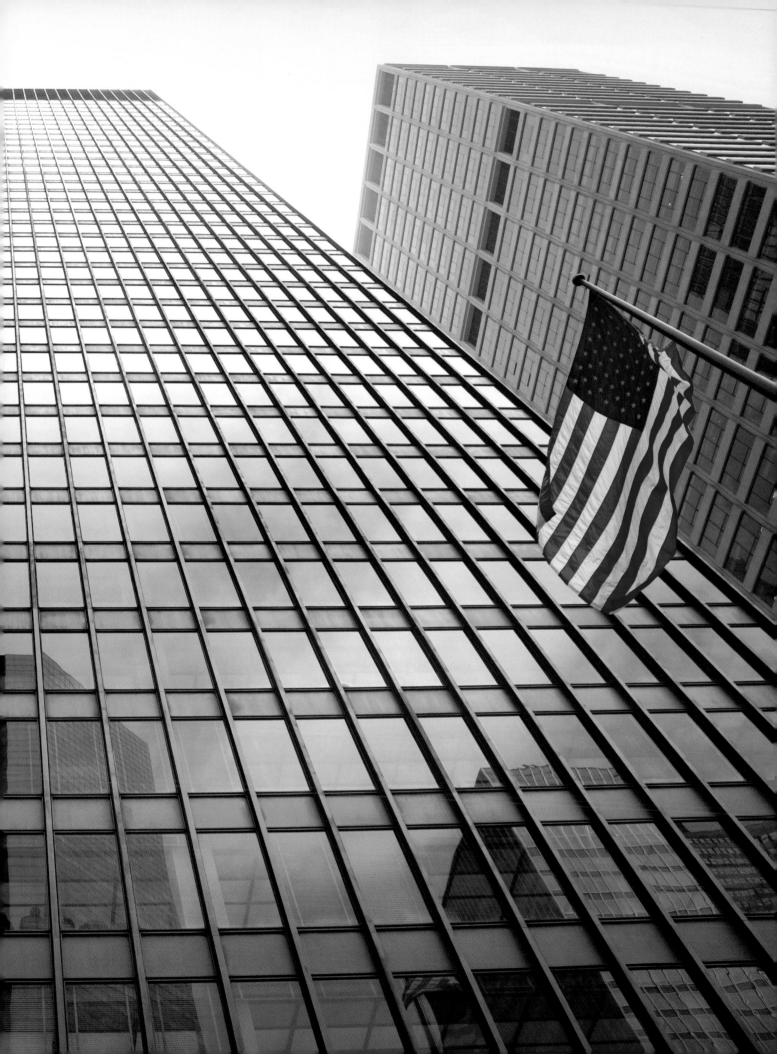

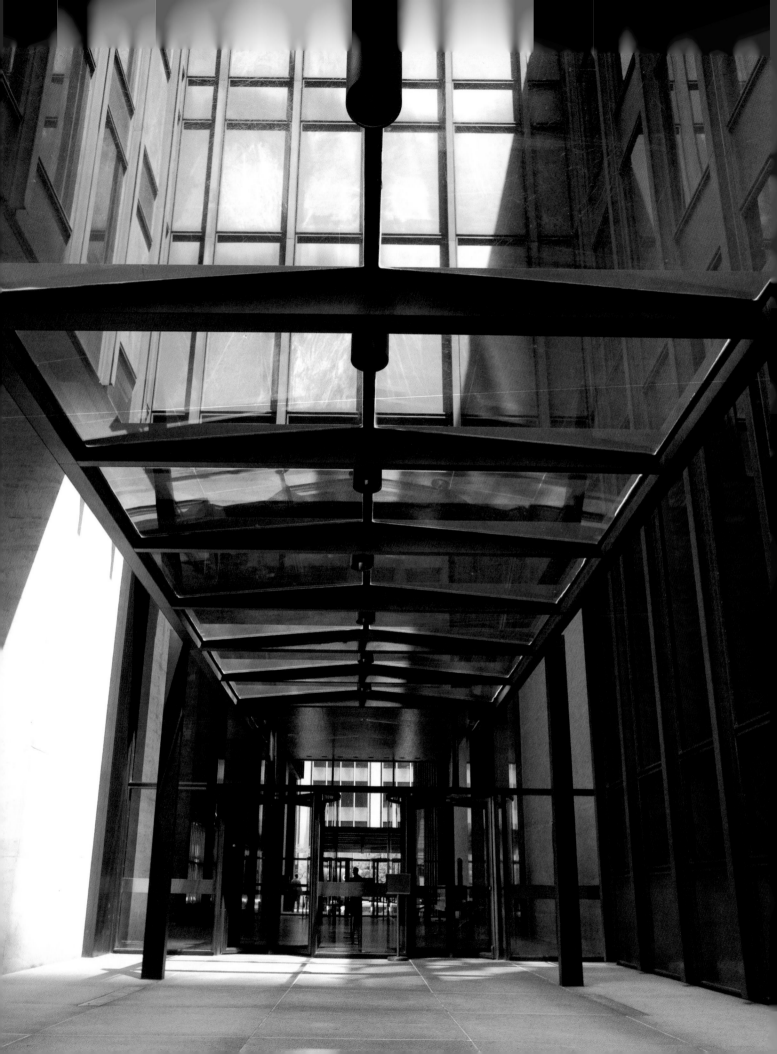

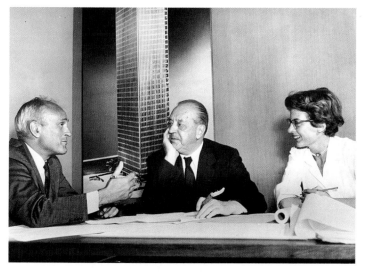

Philip Johnson, Ludwig Mies van der Rohe, and Phyillis Lambert.

This building is so complicated. You know, people look at this building, and they think it's so simple and they just dismiss it, "Oh, another glass building." But, in fact, it's a very, very complicated building.

—BARRY LEWIS, Architectural Historian

When Mies met with Bronfman, he quickly learned that saving money was not on the agenda for the Seagram Building. Bronfman told Mies that he liked bronze, so Mies covered the entire building in bronze. The building has to be regularly wiped with lemon oil to prevent discoloration.

Mies famously said, "God is in the details." And it's the details, some of which were executed by architect Philip Johnson (pictured above), that set apart the Seagram Building. The materials included pale travertine, pink granite, and verde-antique marble. The windows were tinted to match the façade, and the lighting was carefully choreographed.

At first glance, the building seems to show its bare bones. But this is a carefully crafted illusion. The rows of vertical I-beams that Mies placed on the exterior (right) serve little structural function. But they create a subtle shading effect on the façade and remind us of the hidden steel that's actually holding up the building.

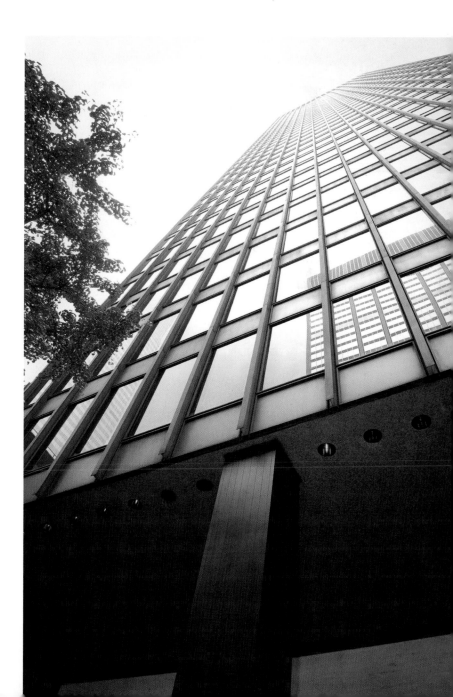

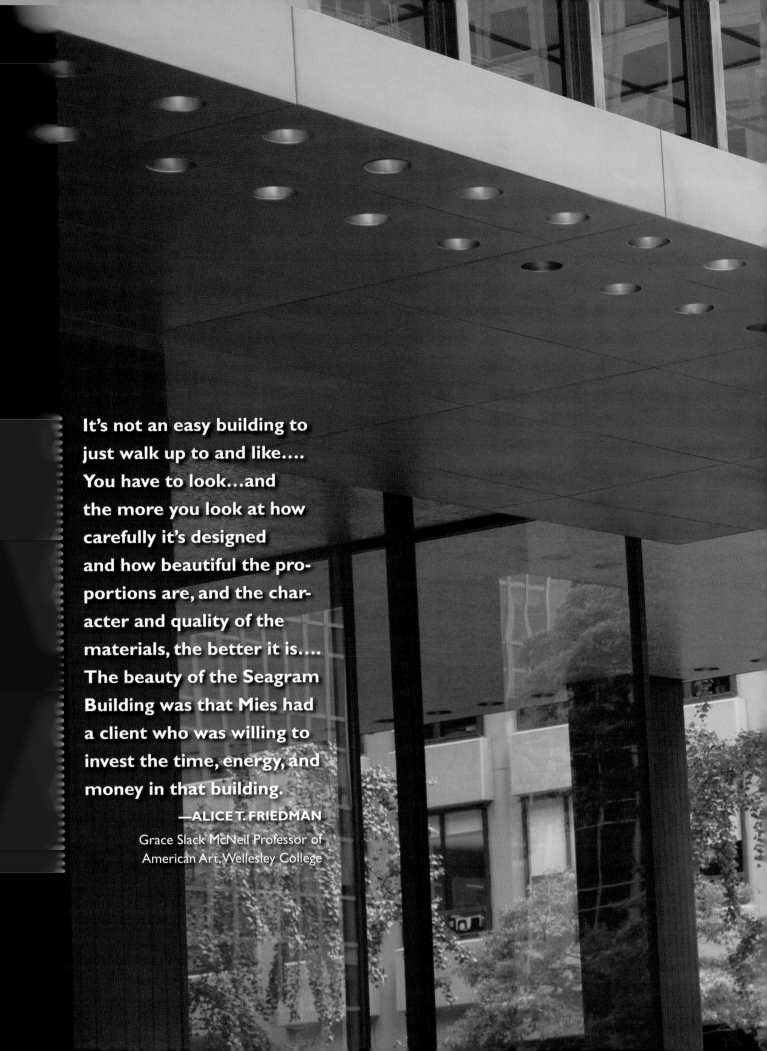

It's not an easy building to just walk up to and like.... You have to look...and the more you look at how carefully it's designed and how beautiful the proportions are, and the character and quality of the materials, the better it is.... The beauty of the Seagram Building was that Mies had a client who was willing to invest the time, energy, and money in that building.

—ALICE T. FRIEDMAN
Grace Slack McNeil Professor of
American Art, Wellesley College

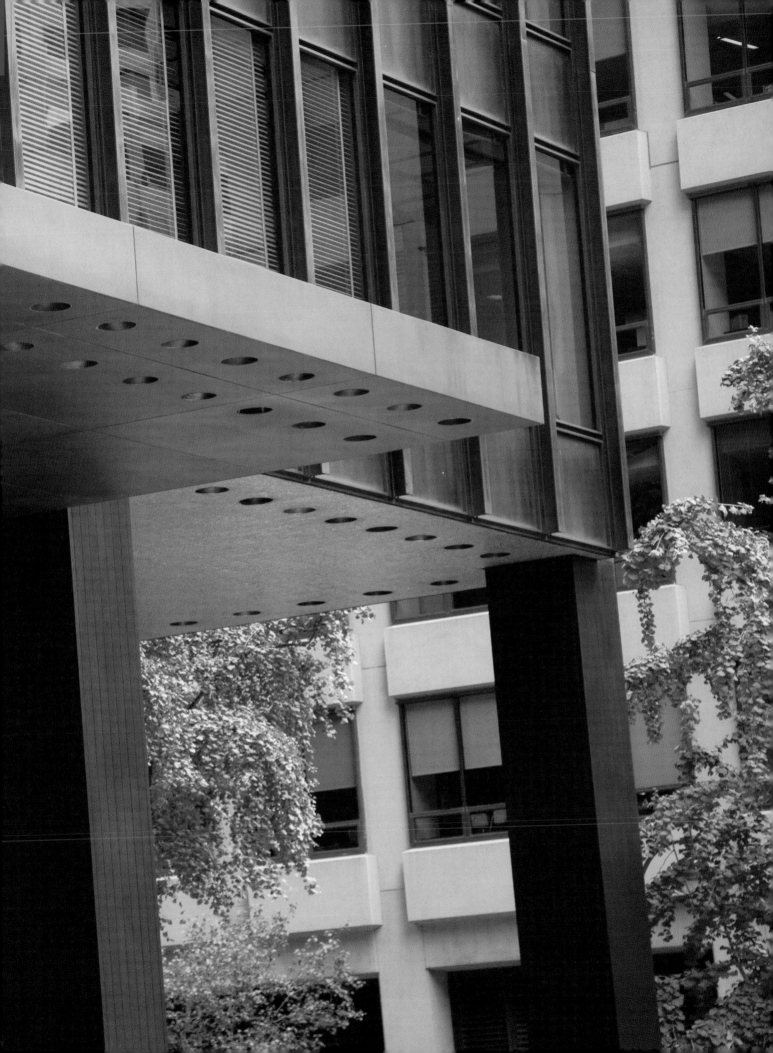

Mies van der Rohe didn't want to design a [stair-step shaped] "set-back" building; he didn't want that.... To have this kind of open plaza in the middle of a congested city was itself a gift to the city.... He saw it as a gentle gift of space and light to a city that was desperate for both of those elements. —BARRY LEWIS

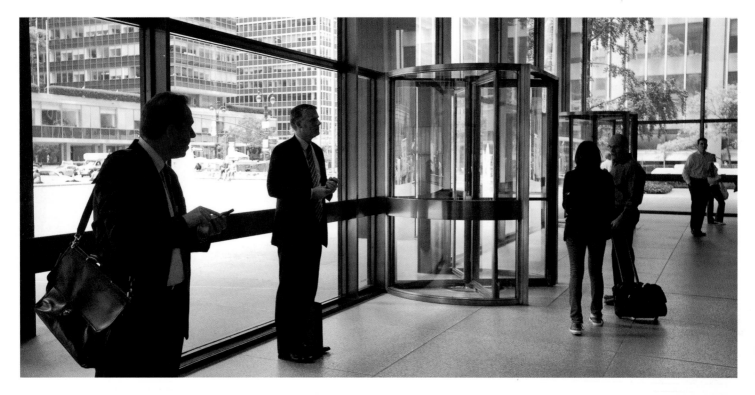

The most striking—and expensive—feature of the Seagram Building is the huge empty space in front. This was Mies's surprising solution to New York's strict zoning code, which since 1916 had prevented skyscrapers from rising straight up like sheer cliffs and blocking out the city's light and air.

The Seagram plaza proved so popular that the city amended its zoning code to encourage architects and developers to build more of them. Over the next 25 years, New York and cities across America saw a proliferation of modernist buildings set on open plazas, but the results were mixed. The plazas were supposed to offer a respite from the hustle and bustle of cities, but they too often became desolate patches of concrete that sucked the life out of their surroundings.

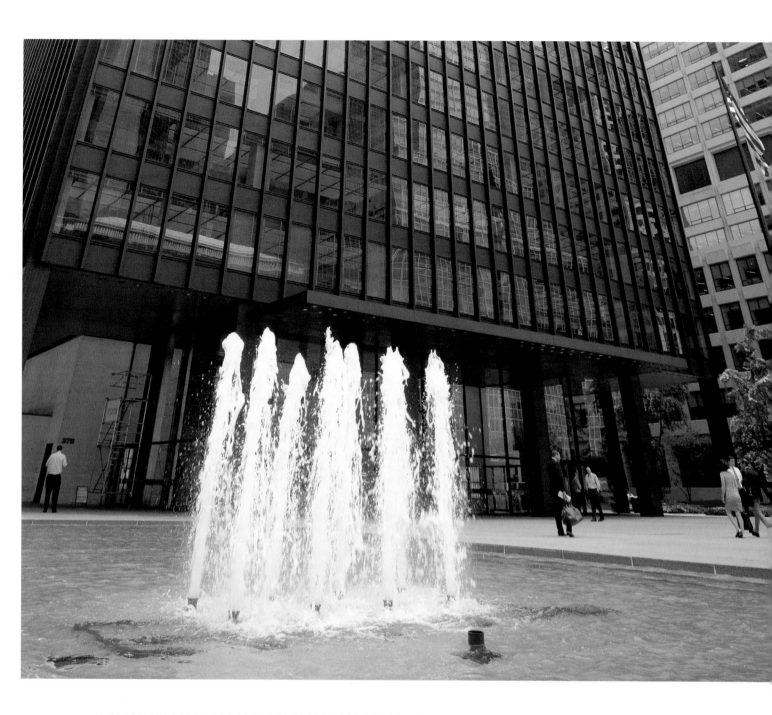

Everyone said, oh, that's so nice the **Seagram** building has that plaza. Everyone loves it. Let's have plazas everywhere…. And gee, funny thing, none of them were as good. And in fact, a lot of them were really horrible! They were awful, ugly, concrete…prison yards.

—PAUL GOLDBERGER

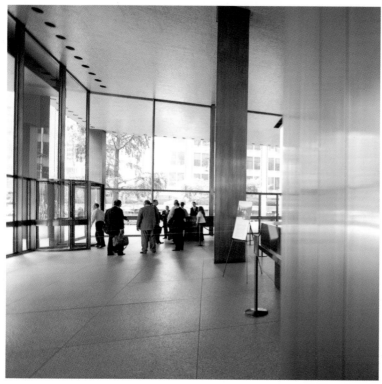

It [Seagram] is a great work
of architecture and a terrible
model. Because everybody
kept trying to knock it off, but
nobody could really do it very
well…. You needed Mies van
der Rohe or somebody of his
caliber to do it properly, and
it created the false impression
that it was an easy model.

—PAUL GOLDBERGER

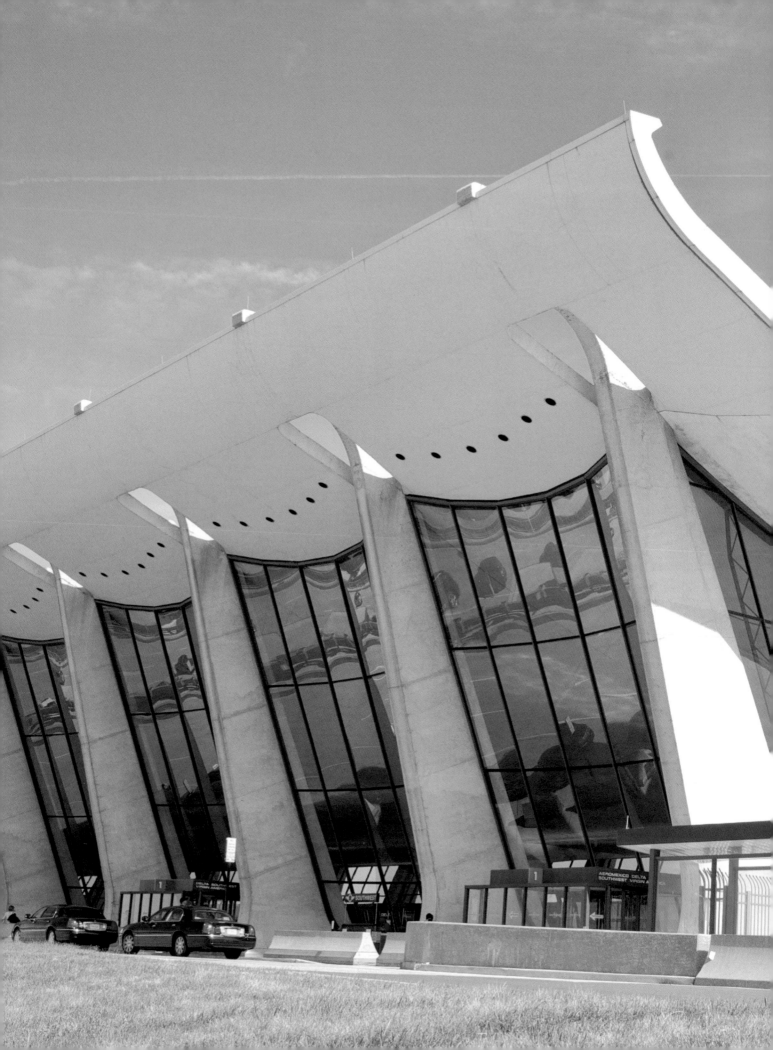

8

DULLES INTERNATIONAL AIRPORT

■ CHANTILLY, VIRGINIA
■ EERO SAARINEN, 1962

In this age of full-body scanners and long lines at airport security, it's almost hard to believe that there was a time when flying could be exciting—even fun. Few airports captured the excitement of early jet travel like Dulles International Airport, located outside of Washington, DC.

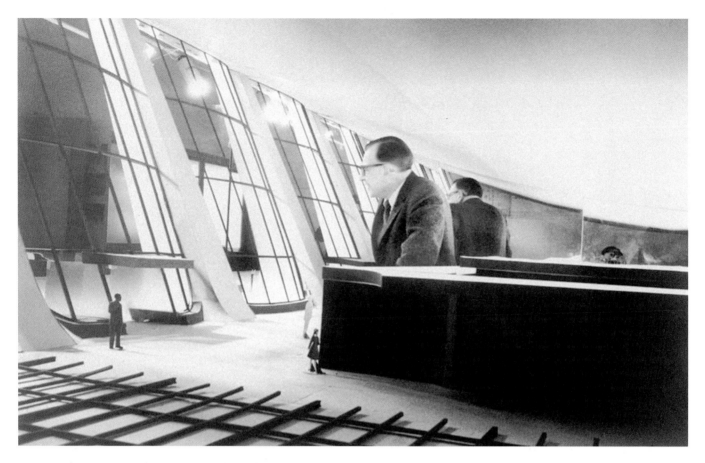

Eero Saarinen, above, standing in a model of Dulles International Airport, and left.

The building has all of the sculptural stylishness for which its architect, Eero Saarinen (above and left), was celebrated. In an era often remembered for its understated glass boxes, Saarinen offered an expressive brand of modernism.

Saarinen was finishing his design for a new TWA terminal in New York when he got the call to design Dulles. This wouldn't be just any airport. It was the first airport in the world built expressly for jets.

Saarinen said this is a different kind of transit....We are transporting ourselves in a new machine and a new era, and we have to represent that.

—REED KROLOFF

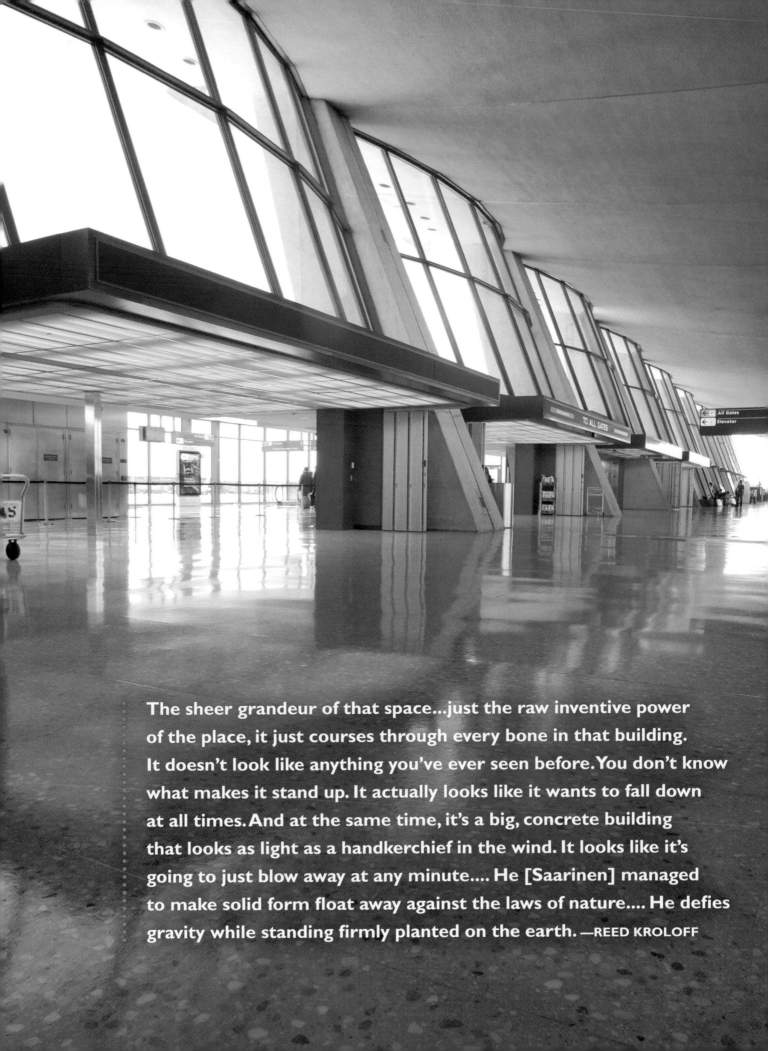

The sheer grandeur of that space...just the raw inventive power of the place, it just courses through every bone in that building. It doesn't look like anything you've ever seen before. You don't know what makes it stand up. It actually looks like it wants to fall down at all times. And at the same time, it's a big, concrete building that looks as light as a handkerchief in the wind. It looks like it's going to just blow away at any minute.... He [Saarinen] managed to make solid form float away against the laws of nature.... He defies gravity while standing firmly planted on the earth. —REED KROLOFF

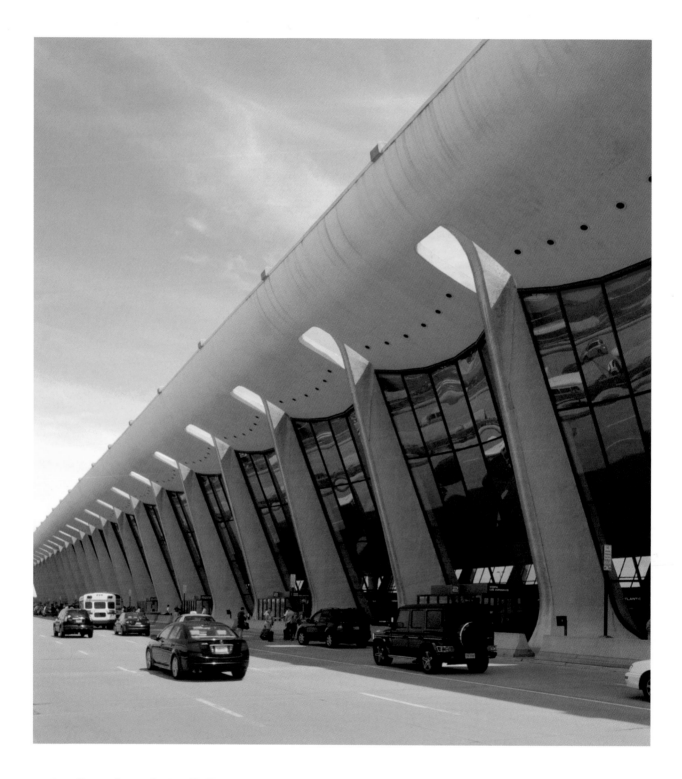

Saarinen's building is an abstracted version of a classical temple.
It has that symmetrical colonnade all along the front...these grand,
tall columns...sort of in keeping with the official architecture,
as many people see it, of Washington, DC.

—**MARTIN MOELLER**, Senior Curator, National Building Museum

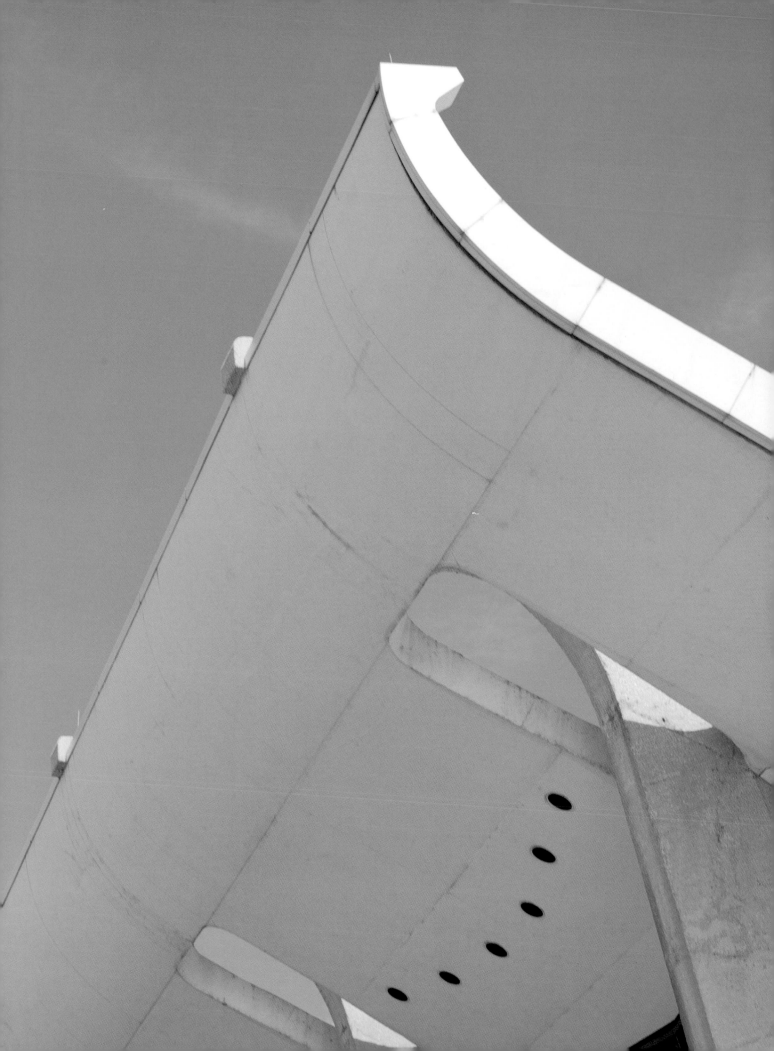

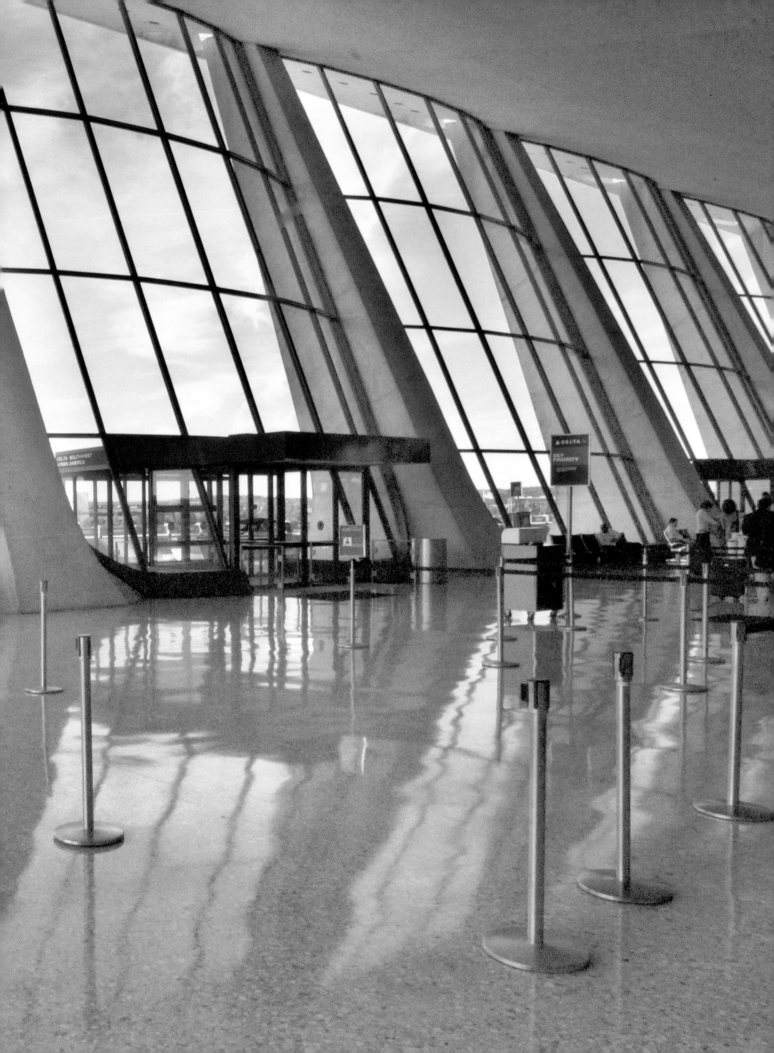

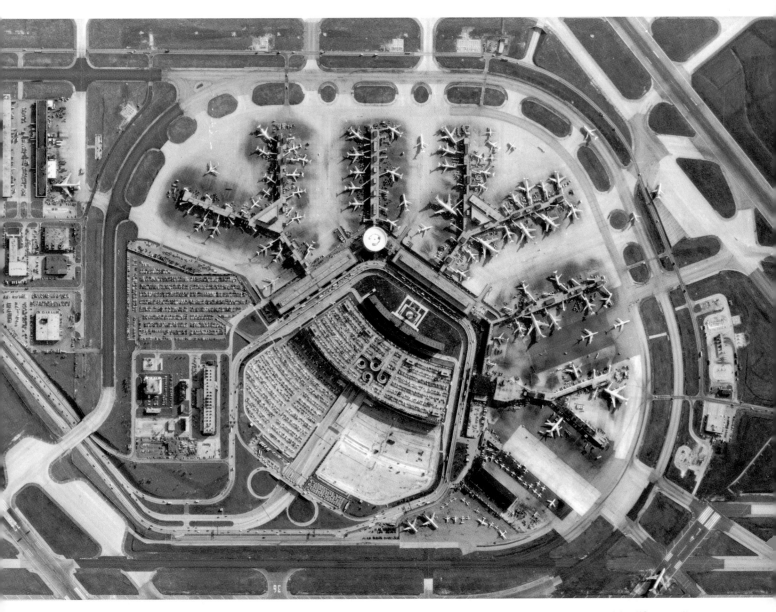

This aerial view of O'Hare International Airport shows terminals expanding from the center like "fingers."

Saarinen took a highly scientific approach to the project. He sent teams of researchers to American airports nationwide armed with clipboards and stopwatches. According to the director of Cranbrook Academy of Art and Art Museum Reed Kroloff, among the things the teams considered were: "How fast do people move from point A to point B? What are their patterns of transit within a building? Why are they going from A to B? Where do we want them to go? Maybe we want them to go from A to C. We need to direct traffic. How do you handle huge pieces of equipment? How do you deal with thousands and thousands of pieces of luggage?"

The airports Saarinen studied were relics of a simpler time, when propeller-driven planes parked right outside a single terminal. To adapt to the oversized needs of jets, airports cobbled together a sprawling expanse of terminal fingers, lounges, and "telescoping gangplanks." The result, Saarinen found, was that passengers had to walk an average of 950 feet to get to their planes.

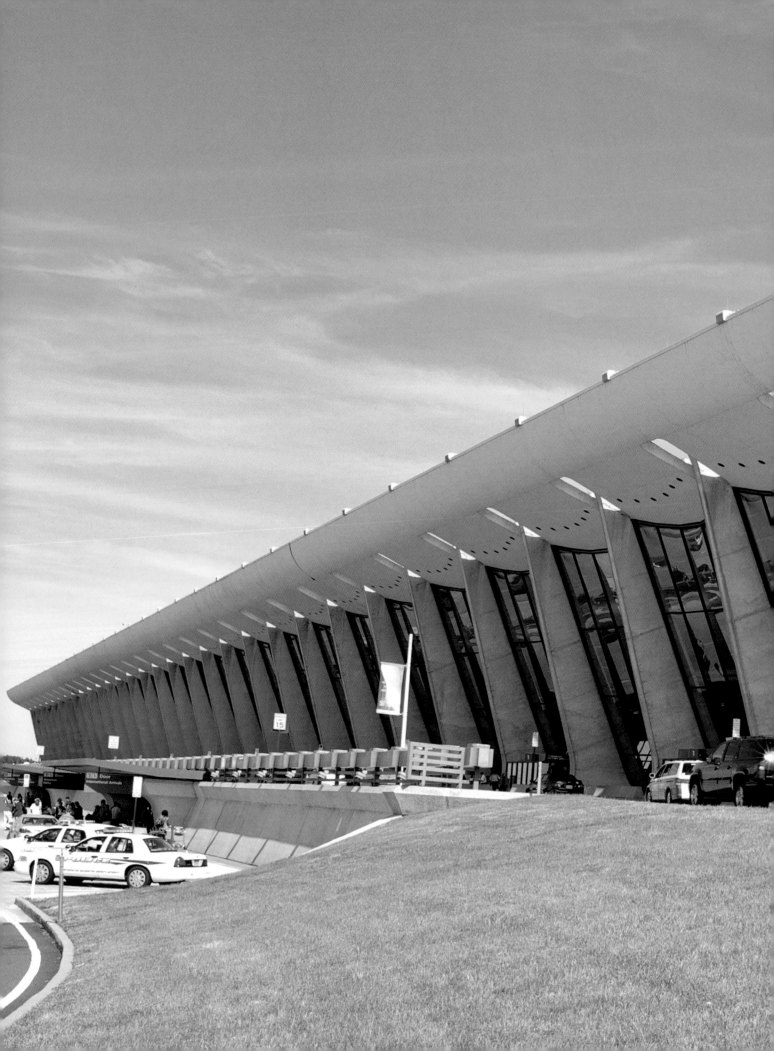

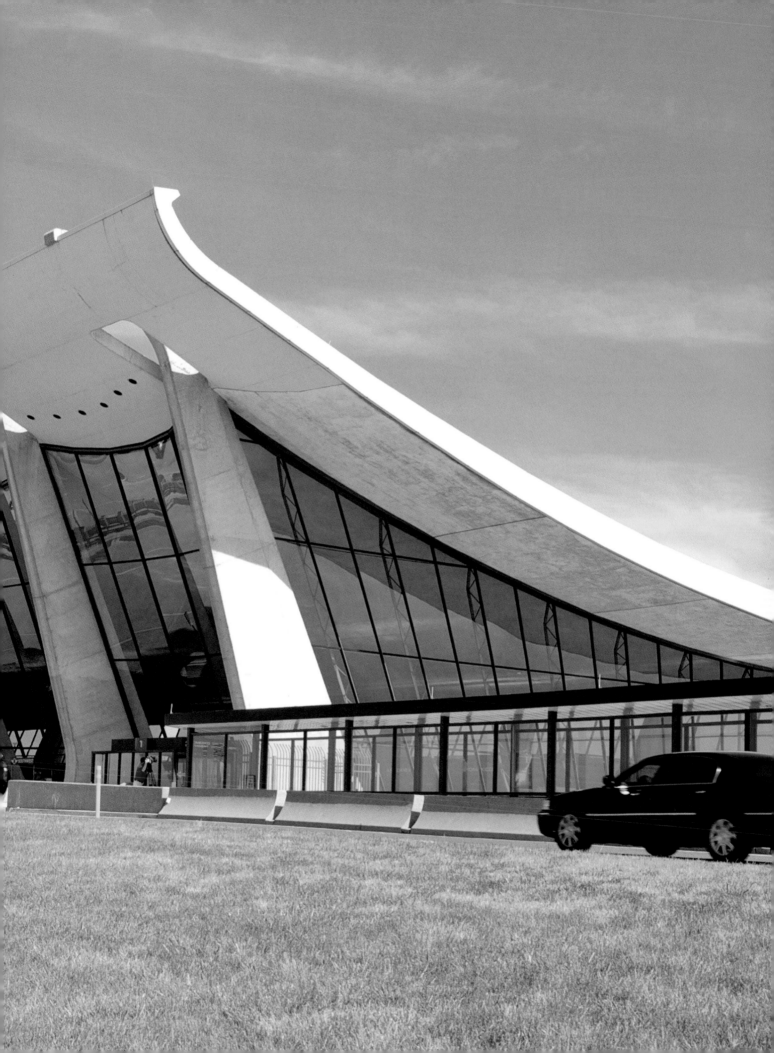

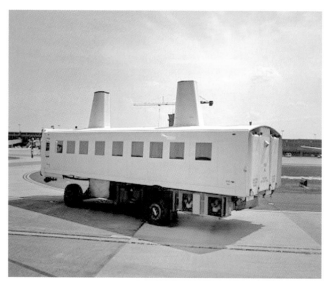

This mobile lounge transported passengers from the terminal to their plane.

At Dulles, Saarinen designed a single, narrow terminal where passengers only had to walk 150 feet. From there, a contraption called a "mobile lounge" (above) whisked them away to their plane. A half-century later, some of these mobile lounges are still in use.

Saarinen wanted Dulles to look like a 20th century portal to the nation's capitol. So he combined jet-age curves with the classicism of Washington, DC. The building's columns hold up the swooping concrete roof in a way the ancient Greeks never could have imagined. Instead of resting on top of the columns, the roof hangs from them, like a huge hammock. The solid concrete appears to float above the undulating glass walls.

Sadly, Saarinen never got to see the completed airport. He died suddenly from a brain tumor at age 51. But the weightless form he created left a permanent mark on American architecture. Some airport architects overtly copied Dulles, while others were generally inspired by his vision for what an airport should be: a well-ordered and welcoming gateway to a city.

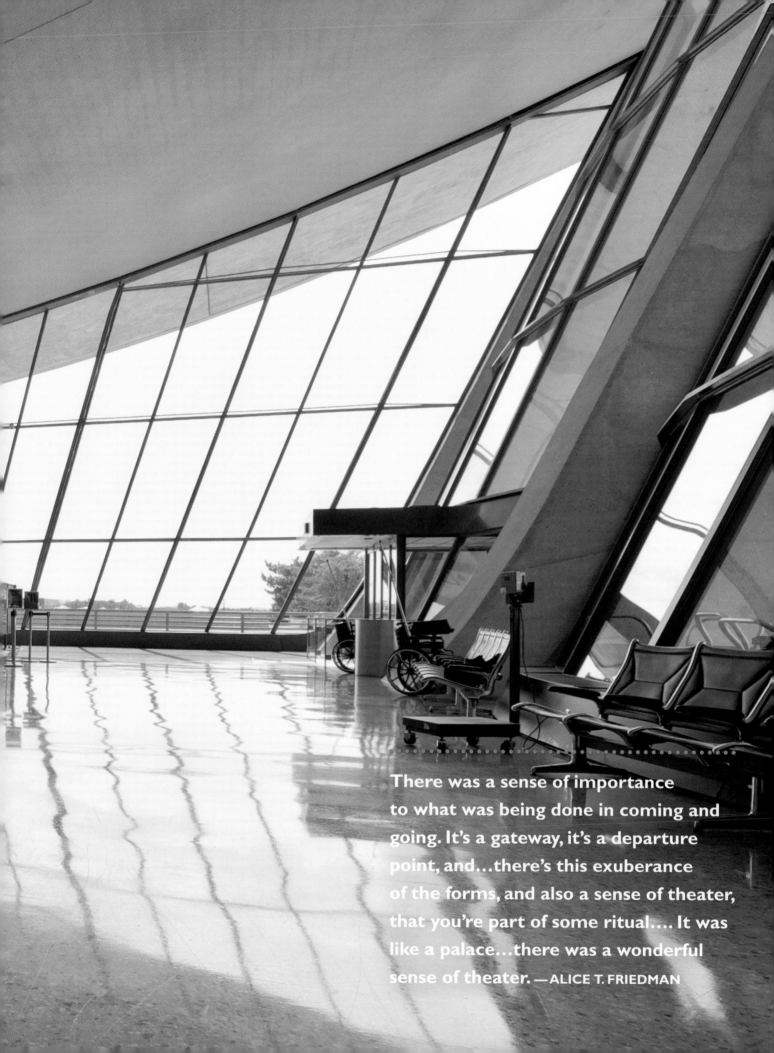

There was a sense of importance to what was being done in coming and going. It's a gateway, it's a departure point, and…there's this exuberance of the forms, and also a sense of theater, that you're part of some ritual…. It was like a palace…there was a wonderful sense of theater. —ALICE T. FRIEDMAN

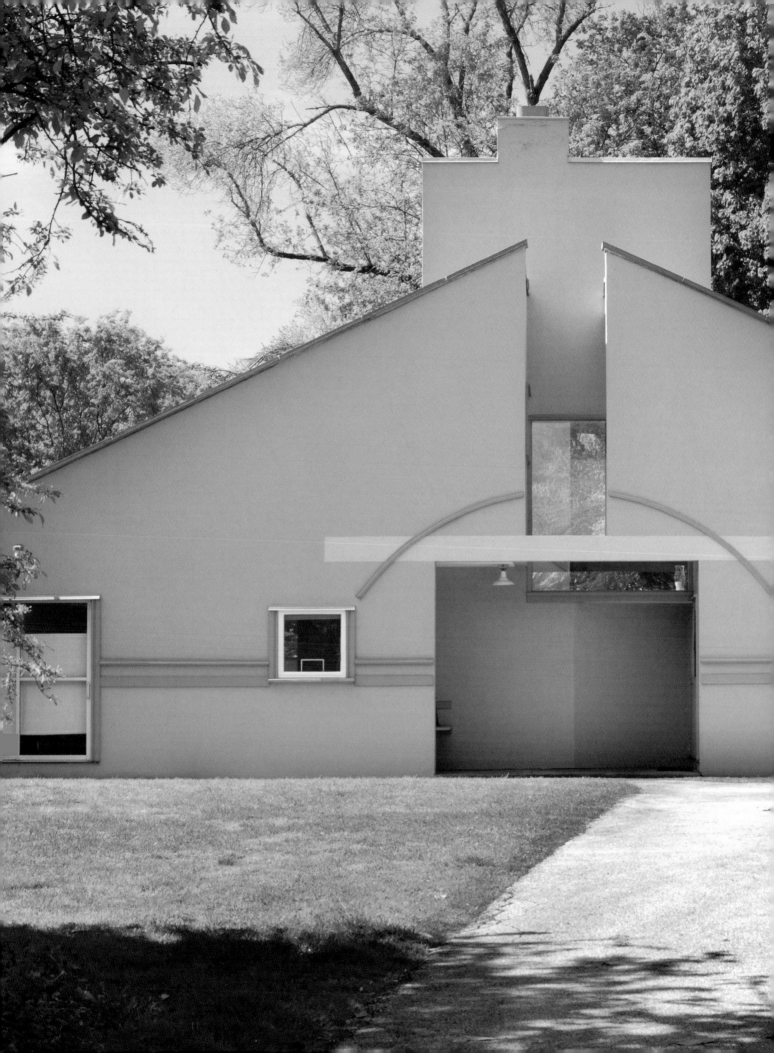

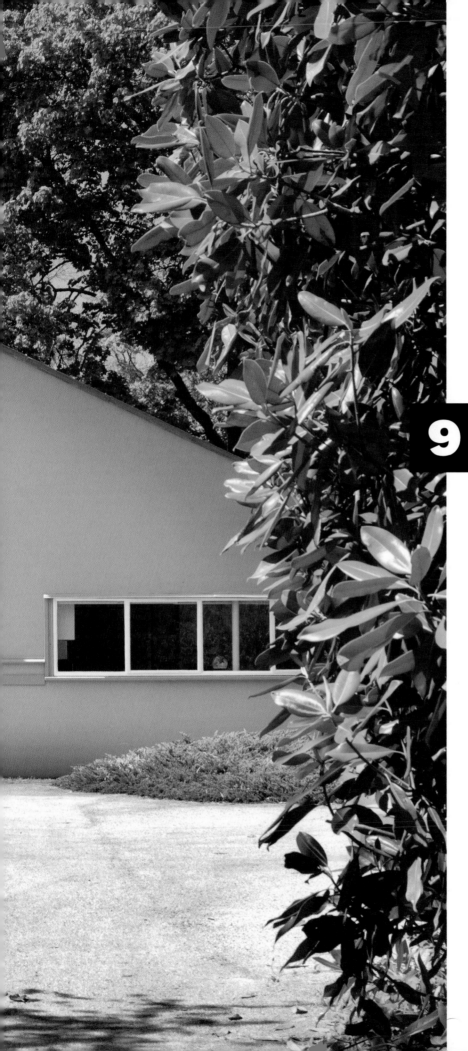

Vanna Venturi House

■ PHILADELPHIA, PENNSYLVANIA
■ ROBERT VENTURI, 1964

It's a little house that sparked a very big debate. Robert Venturi thumbed his nose at modernism with his design for this Philadelphia house. His client was his elderly mother. Like her son, Vanna Venturi wasn't afraid to go against the grain. She was a socialist and a pacifist. Her countercultural views made her an ideal client for an architect who wanted to challenge the modernist establishment.

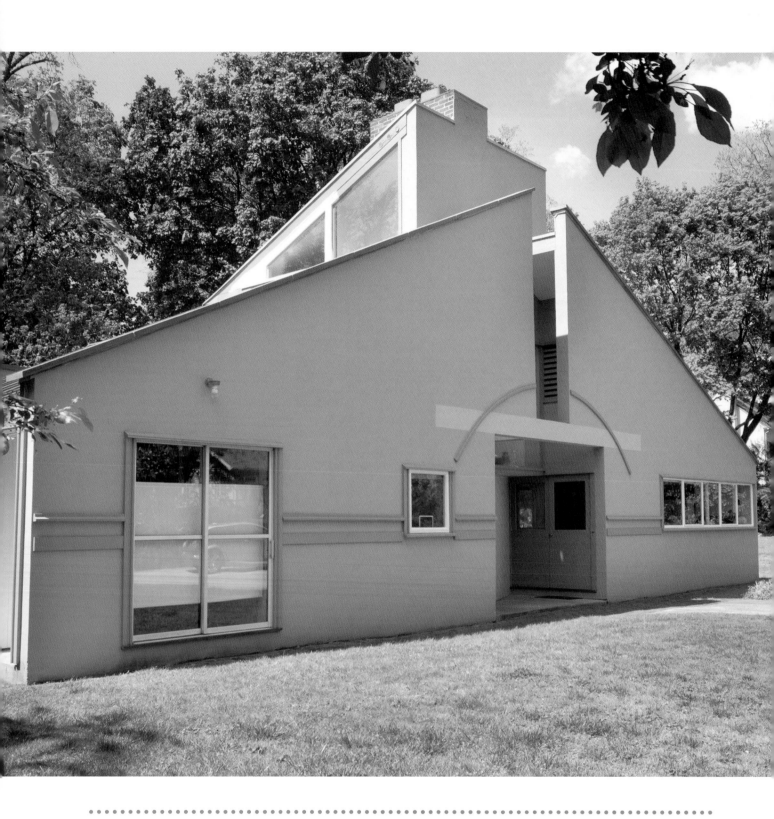

It looks like a pitched roof Monopoly box house that every kid would have ever seen before.... But when you start to look at it closely, nothing works right, nothing is what it seems to be. —REED KROLOFF

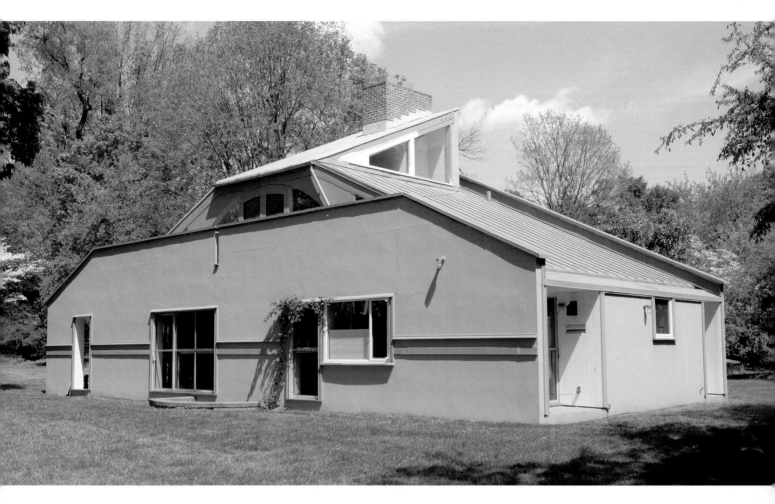

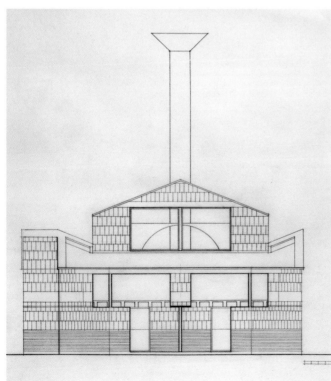

A sketch of an early design for the Vanna Venturi House with a suggestive chimney.

Robert Venturi's problem with modernist architects was that they tried to meet the complicated needs of our society with grand schemes and rigid rules. The result, he felt, were bland buildings that didn't respond to the real needs of human beings. Ludwig Mies van der Rohe had famously declared, "Less is more." Robert Venturi shot back, "Less is a bore."

The house was to be something of a manifesto against modernism, but its design didn't come easily for the architect. From 1959 to 1963, he designed and redesigned the Vanna Venturi House. In particular, he labored over the unusually tall chimney, which he claimed was an obscene gesture directed at the establishment (left).

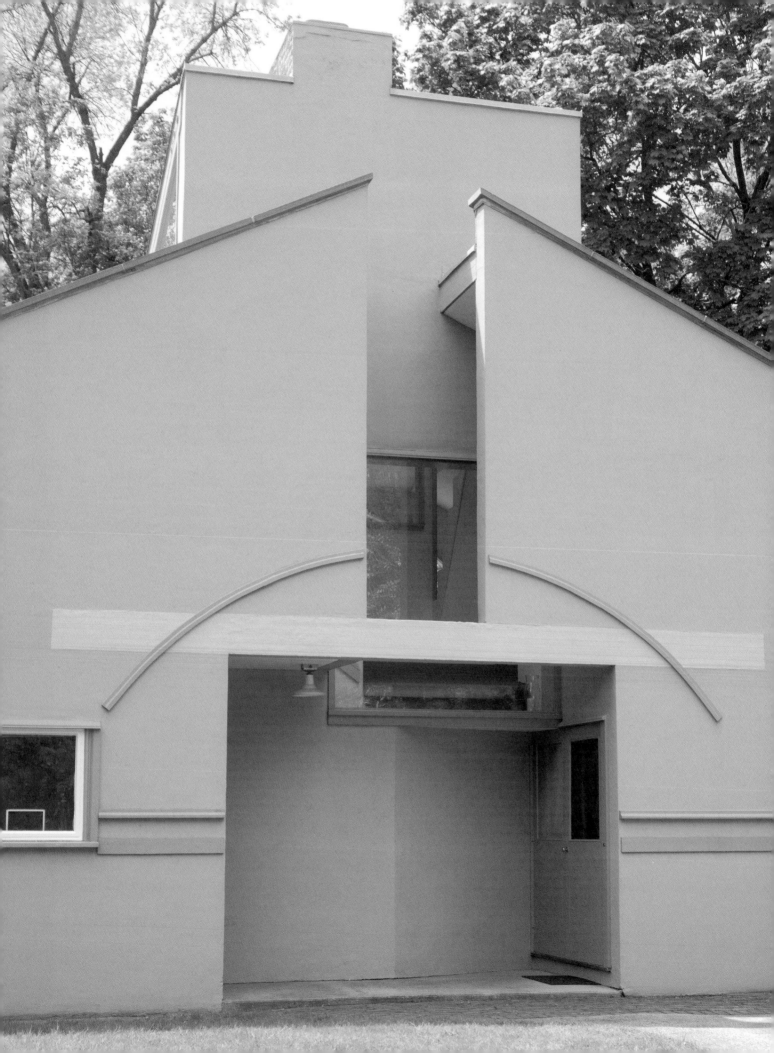

Robert Venturi stands in front of models of the Vanna Venturi House.

Instead of building an abstract modernist box, he ended up designing a house that looks vaguely familiar—almost like a child's drawing of a house. He borrowed familiar elements that had been used by homebuilders throughout history. "I was just trying to use ordinary, in a nice sense of the word, elements," said Robert Venturi. "I was trying not to be dramatic, not to be original, although I was being original by not being original." His wife, the architect Denise Scott Brown, shared his vision: "That's part of [his moving away] from modernism where everything had to be extraordinary, revolutionary.... We're saying we're tired of a house having to have a flat roof because that was being revolutionary. Why does it have to be? What do most houses have? What's the reality?"

As you look more closely at the Vanna Venturi House, you discover that it's much more complicated than a child's drawing. What looks like a huge chimney can't be real, because it has windows through which one sees stairs, not smoke (see opposite page). What appears to be a gable roof projects above the real roof. And the entrance arch can't be holding anything up because it's broken in the middle, and it's superimposed over a real load-bearing beam. In the living room, an oversized fireplace jockeys for position with a stairway that Brown calls "illogical." The stairs widen at first, but then they narrow to make way for a real chimney. The idea behind the peculiar design is that while modernists fought so hard to create order, Venturi recognized awkwardness and confusion, and his house embraced "complexity and contradiction in architecture" (hence the title of his influential book, *Complexity and Contradiction in Architecture*).

It's important for there to be that contradiction, that the building should always come around and surprise you. And that the idea that the building or an architect has the capacity to come up with the perfect ideal form in three dimensions is a flawed idea.

—ALICE T. FRIEDMAN

Not long after moving in, Vanna Venturi started receiving visitors on her doorstep—by the busload. Many of them were young architects for whom the house had become a source of inspiration (and sometimes consternation). As Robert Venturi recalled, "She enjoyed talking to them and telling them stories about her son when he was a little boy and all that. That's the price they pay for looking at the house." Many of those young architects took away ideas that became part of a new style known as "postmodernism," although Robert Venturi himself rejected that label.

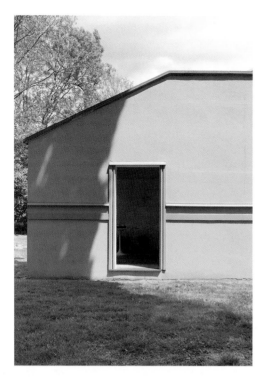

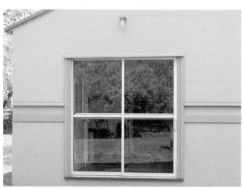

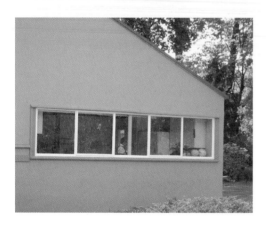

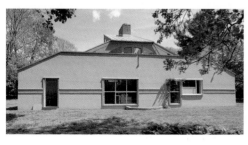

He [Venturi] said if you look at the history of architecture, it's not so simple. We've always done buildings that were funny and did weird things and weren't absolutely consistent. And that's how life is. Why should we be reducing architecture to a false simplicity?

—PAUL GOLDBERGER

Many postmodern buildings lacked the complex ideas and dynamism of the Vanna Venturi House. Instead, real estate developers and their clients saw postmodernism as a cheap and easy way to brand their buildings. They simply slapped historical allusions on a billboard-like façade. Robert Venturi worked to liberate architecture from the tyranny of modernism, but against his wishes, he helped create a new "ism." He said, "I wasn't trying to be anti-modern or postmodern or anything. It was just sort of my interpretation of modern…. I just didn't even think of things like that…. My approach was misunderstood…. Don't trust an architect who's trying to start a move-ment. An artist just wants to do a very good job."

Robert Venturi and Denise Scott Brown in the dining area of the Vanna Venturi House.

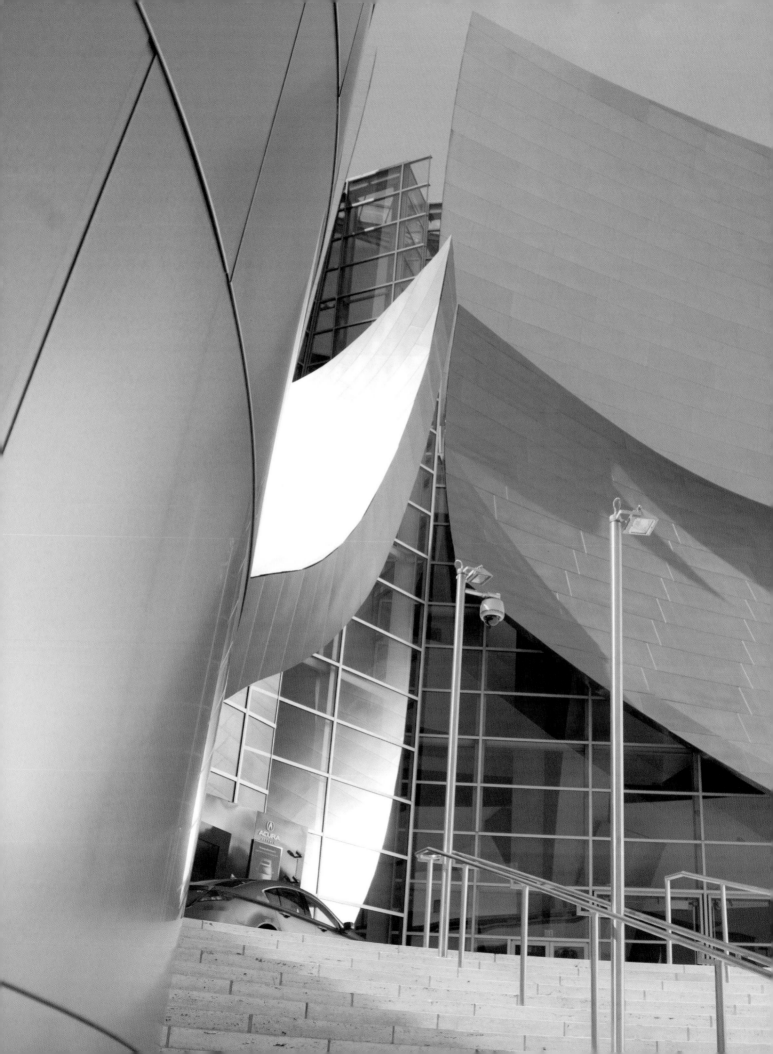

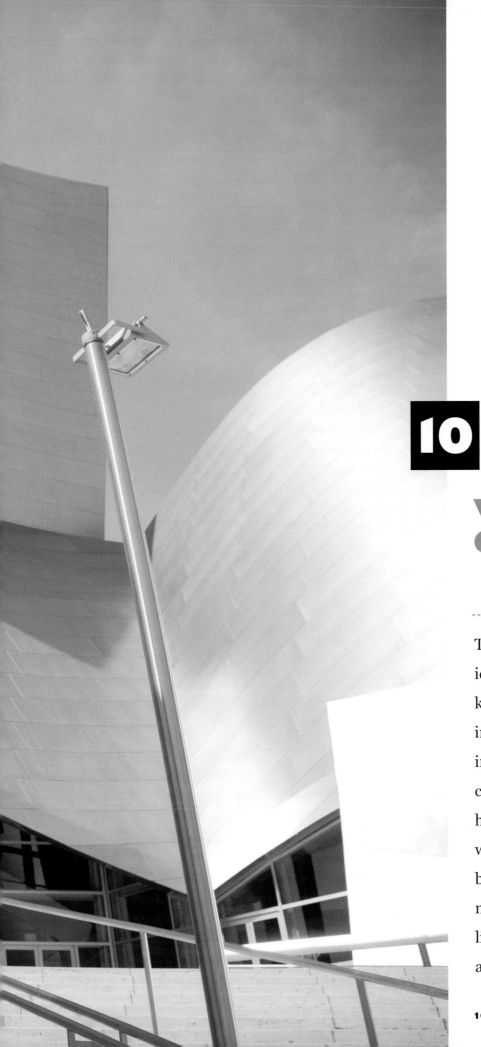

10

WALT DISNEY CONCERT HALL

- LOS ANGELES, CALIFORNIA
- FRANK GEHRY, 2003

Today Frank Gehry is arguably America's most acclaimed living architect, known for building splashy cultural institutions around the world. But back in 1988, he was a long shot in the competition to design a concert hall in his own hometown. At the time, Gehry was known for his funky, low-budget buildings, made with materials that are never found in a classical concert hall, like exposed plywood, corrugated metal, and chain-link fence.

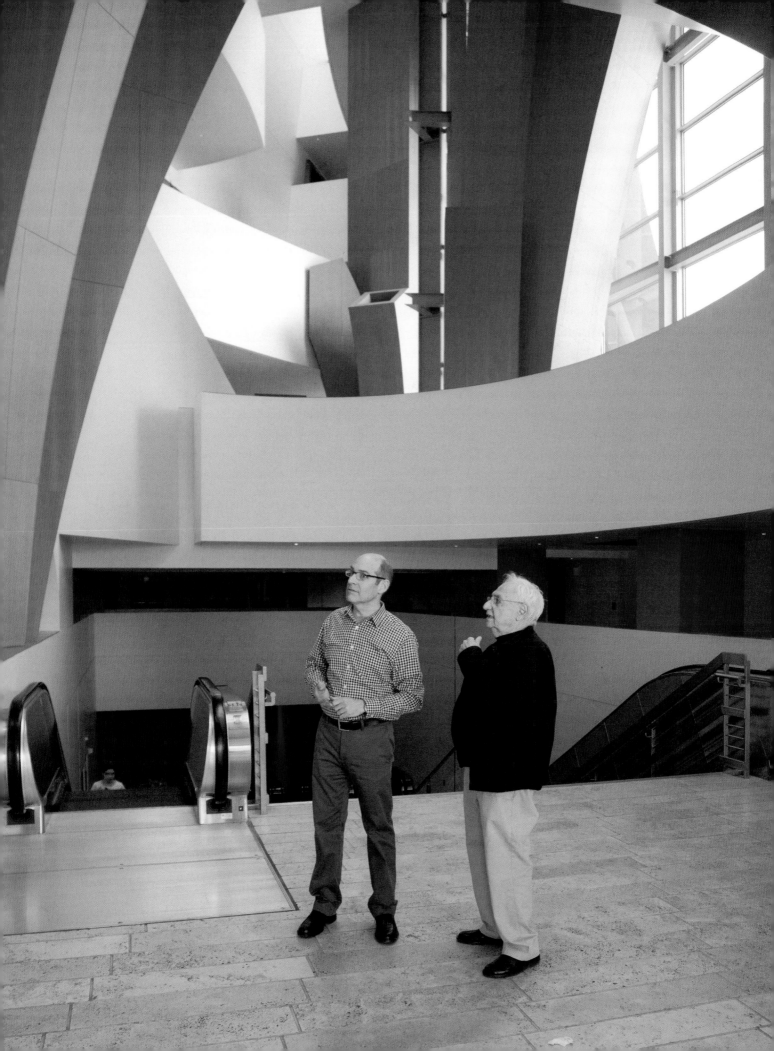

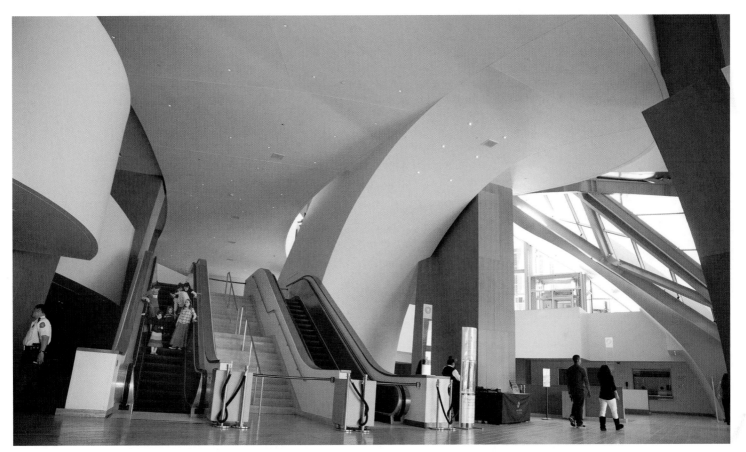

When Gehry entered the competition to design the Walt Disney Concert Hall, he says a Disney family lawyer had a word with him. "He informed me that under no circumstances would Walt Disney's name be on any building that I designed.... They didn't want chain link and corrugated metal," Gehry explained. Undeterred, he submitted a design inspired by the populist spirit of Walt Disney himself. While a classical music venue could end up feeling stuffy and elitist, Gehry wanted this one to be inviting and accessible. "I always thought Walt Disney stood for creativity. I never thought that I was going to make Mickey Mouse and things all over the place," he said.

Frank Gehry shows Geoffrey Baer the sculptural forms in the lobby of the Disney Concert Hall.

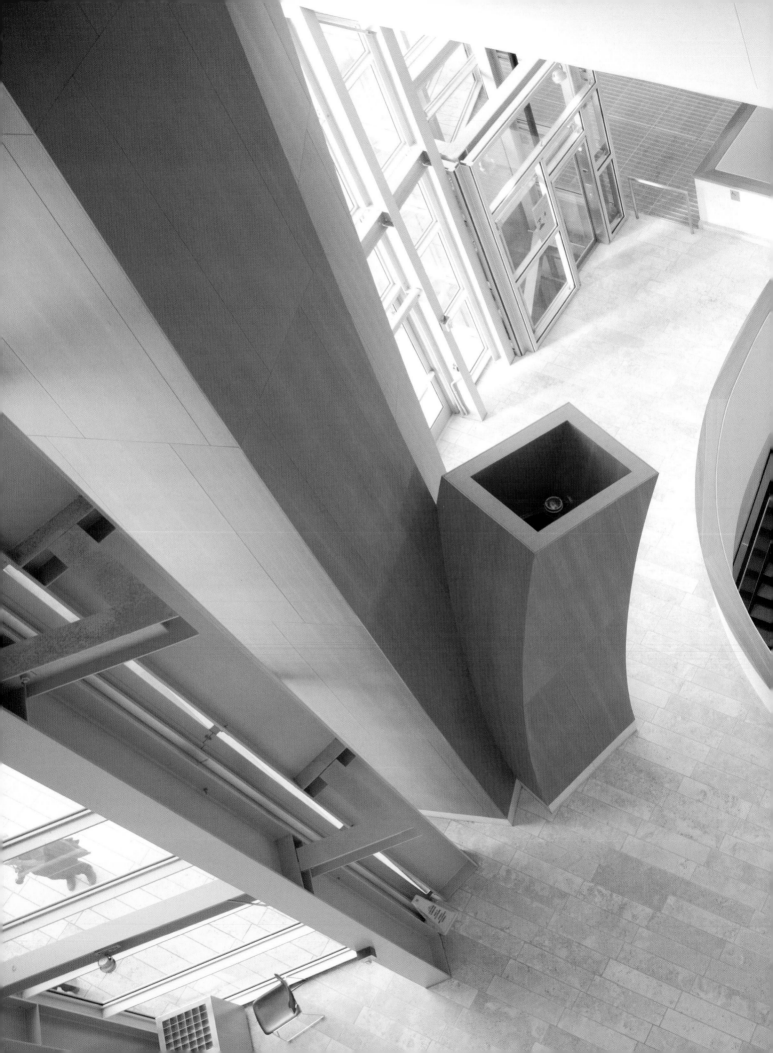

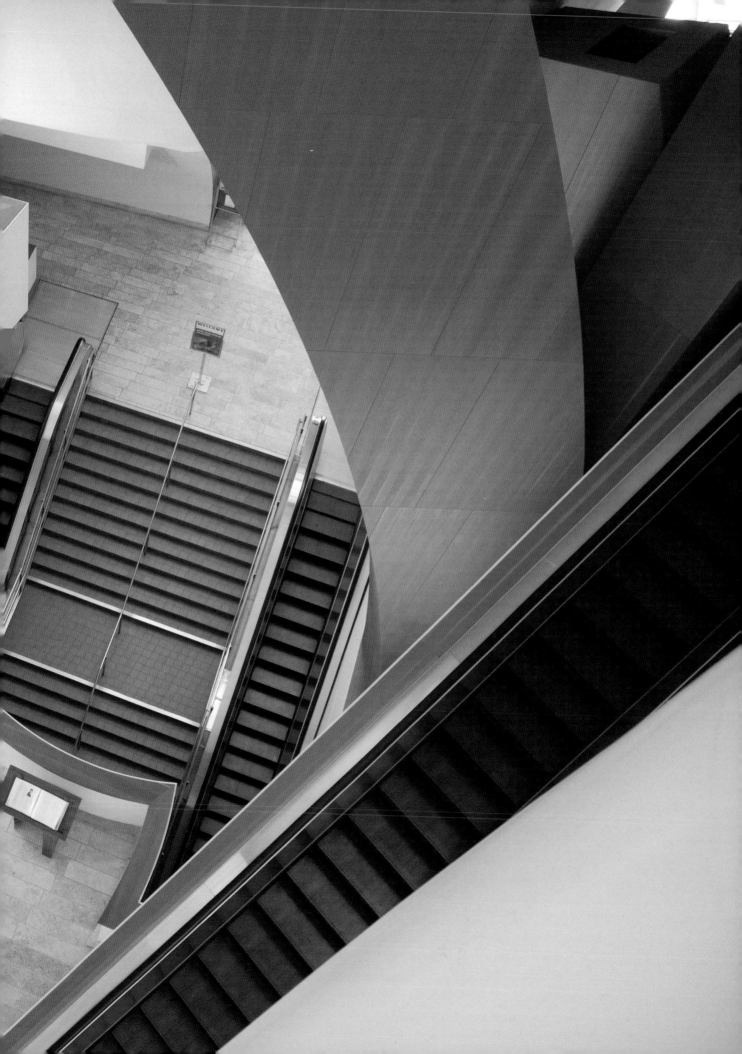

Gehry (pictured below with a scale model of his winning design) got the job. He remembered: "It was that design that caught Mrs. Disney's eye.... She went in and looked at them [the entries] by herself, and she picked ours.... It was startling. It was great...I couldn't believe it." But because of a long string of financial and political problems, another 15 years would pass before he could finish the building. And while he hung onto the populist spirit of his winning entry, over those years he would completely redesign the building from the inside out.

Working with an acoustical consultant, Gehry found that a box-shaped hall produced the best sound. But within the confines of that container, he created a feeling of intimacy between the orchestra and the audience with a sculptural, saddle-shaped seating deck that draws the audience around the orchestra (opposite page).

The billowing shapes inside the building are echoed on the outside in stainless steel (see photo on pages 130-131). These "sails," inspired by Gehry's love of sailing, form a "wrapper" around the building that both refers to the concert hall inside and masks the structure's more mundane inner-workings like restrooms and hallways. In certain places, the shapes relate to the neighboring architecture, including the old music hall across the street. But the building proved less than considerate of another neighbor. One shiny exterior surface reflected sunlight into the condos across the street. "This could have burned the whole house down," Gehry said. "It was a construction mistake. Thank God the lady complained."

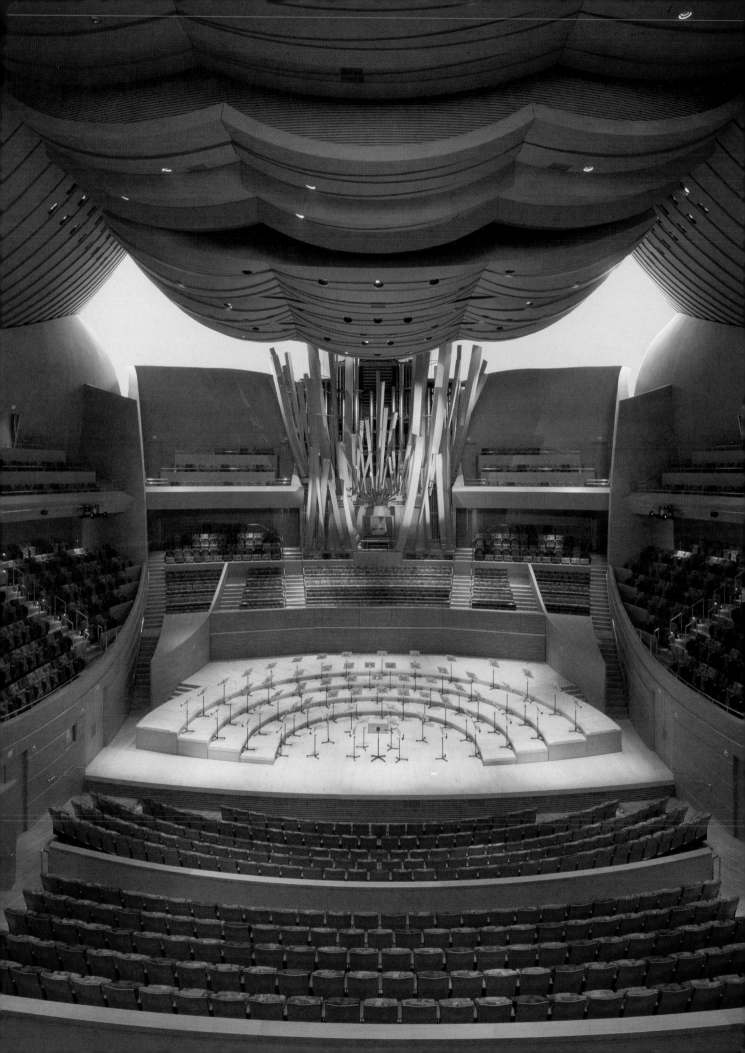

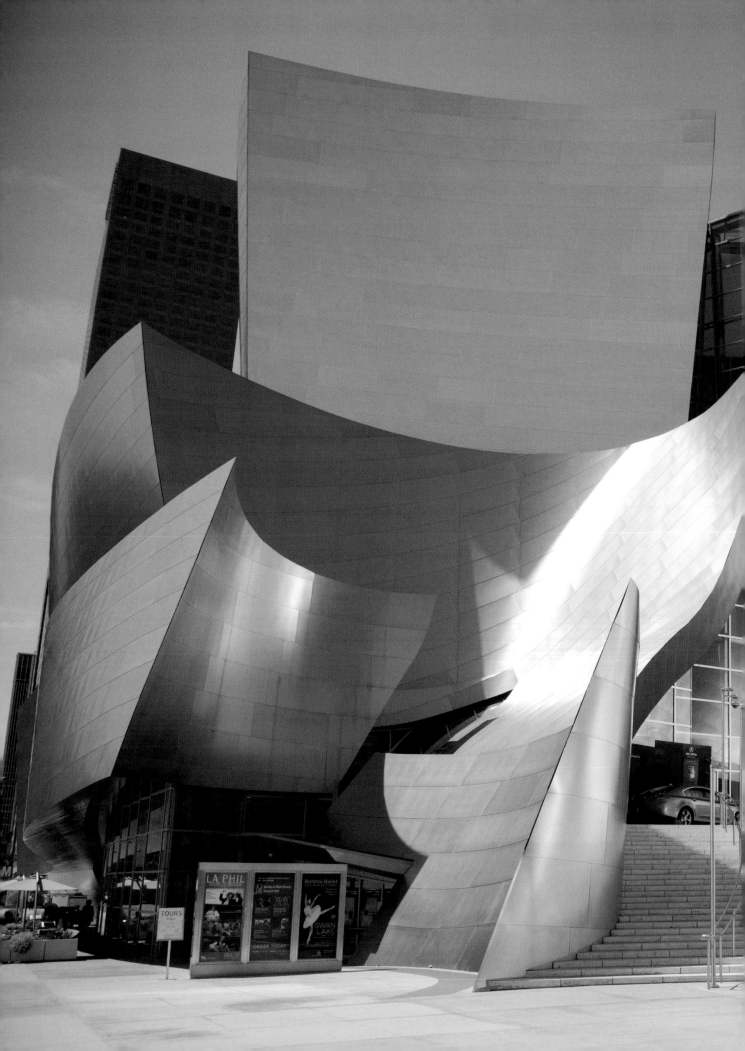

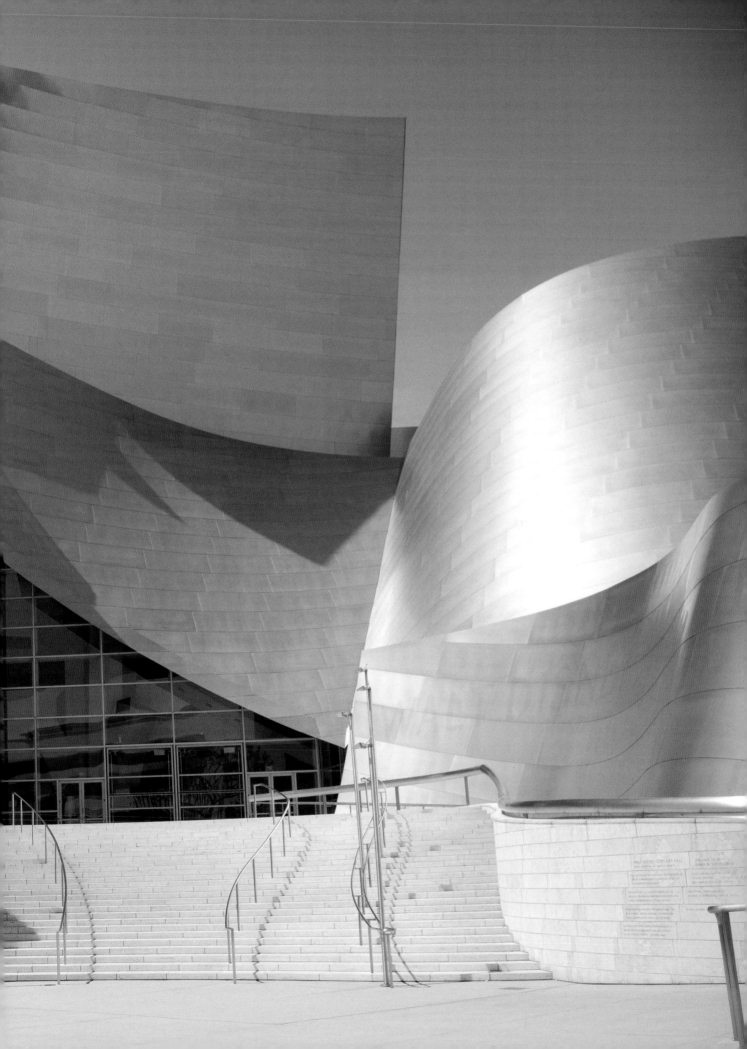

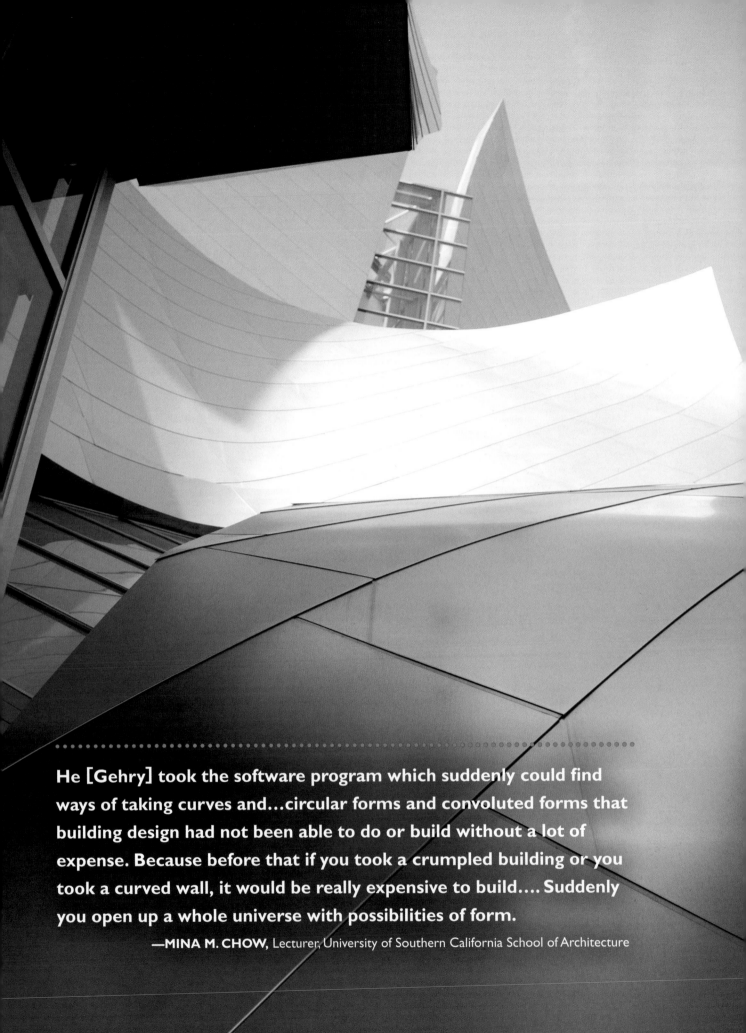

He [Gehry] took the software program which suddenly could find ways of taking curves and...circular forms and convoluted forms that building design had not been able to do or build without a lot of expense. Because before that if you took a crumpled building or you took a curved wall, it would be really expensive to build.... Suddenly you open up a whole universe with possibilities of form.

—**MINA M. CHOW,** Lecturer, University of Southern California School of Architecture

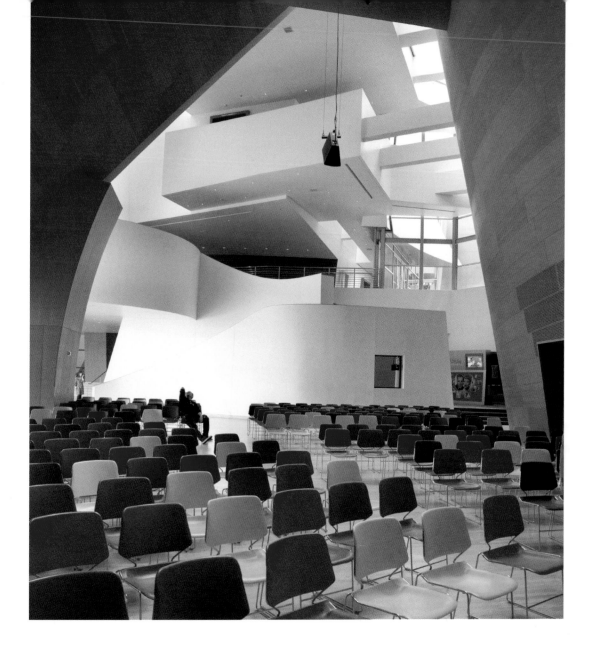

The highly complex forms of the Walt Disney Concert Hall would have been impossible (or far too expensive) to construct in the era before computers. Gehry's office has transformed the architecture industry through its use of software originally created for designing fighter jets. The computer program helped translate the architect's handmade models into three-dimensional steel.

Gehry's unique forms have rarely been emulated by other architects. But his pioneering technology and daring spirit have offered architects and clients a new model for designing successful public spaces by using adventuresome architecture.

I think Frank Gehry has changed architecture…. It [Disney Hall] set the bar higher….There are no copies— nobody can do a Frank Gehry…it's his special, personal expression…. Disney Hall liberates the experience of everybody who walks by it or goes in to hear music…. And I think in the same way this has liberated architects to be bold.

—MICHAEL WEBB, Architecture Writer

BIBLIOGRAPHY

VIRGINIA STATE CAPITOL

Brodie, Fawn M. *Thomas Jefferson: An Intimate History.* New York: W.W. Norton, 1974.

Brownell, Charles E. "Laying the Groundwork: The Classical Tradition and Virginia Architecture, 1770–1870." In *The Making of Virginia Architecture,* edited by Charles E. Brownell. Richmond: Virginia Museum of Fine Arts, 1992.

———. "Virginia State Capitol." In *The Making of Virginia Architecture,* edited by Charles E. Brownell. Richmond: Virginia Museum of Fine Arts, 1992.

Buchanan, James, and William Hay. "Letters to Jefferson Relative to the Virginia Capitol." *William and Mary Quarterly,* 2nd ser., no. 5 (April 1925): 95–98.

Eberlein, Harold Donaldson. *The Architecture of Colonial America.* Boston: Little, Brown, 1915.

Frary, I. T. *Thomas Jefferson, Architect and Builder.* 3rd ed. Richmond, VA: Garrett and Massie, 1950.

Gordon-Reed, Annette. *Thomas Jefferson and Sally Hemings: An American Controversy.* Charlottesville: University Press of Virginia, 1997.

Hitchcock, Henry-Russell. *Architecture: Nineteenth and Twentieth Centuries.* Harmondsworth, UK: Penguin Books, 1968.

Hitchcock, Henry-Russell, and William Seale. *Temples of Democracy: The State Capitols of the U.S.A.* San Diego: Harcourt, 1976.

Howard, Hugh. *Thomas Jefferson: Architect: The Built Legacy of Our Third President.* New York: Rizzoli, 2003.

Jefferson, Thomas. *Autobiography of Thomas Jefferson.* New York: Capricorn Books, 1959.

Kimball, Fiske. *American Architecture.* New York: AMS Press, 1928.

———. *The Capitol of Virginia: A Landmark of American Architecture.* Richmond: Virginia State Library and Archives, 1989.

Kimball, Fiske, and George Harold Edgell. *A History of Architecture.* Westport, CT: Greenwood Press, 1972.

Library Company of Philadelphia. "Death Masks and Life Masks." http://www.librarycompany.org/artifacts/masks.htm.

Library of Virginia. "Beyond Jefferson: Changes to Virginia's State Capitol." http://www.lva.virginia.gov/exhibits/capitol/beyond/.

McInnis, Maurie D. "George Washington: Cincinnatus or Marcus Aurelius?" In *Thomas Jefferson, the Classical World, and Early America,* edited by Peter S. Onuf and Nicholas P. Cole. Charlottesville: University of Virginia Press, 2011.

Miller, John Chester. *The Wolf by the Ears: Thomas Jefferson and Slavery.* New York: Free Press, 1977.

O'Neal, William B. *Jefferson's Fine Arts Library: His Selections for the University of Virginia Together with His Own Architectural Books.* Charlottesville: University Press of Virginia, 1976.

Pierson Jr., William H. *American Buildings and Their Architects: The Colonial and Neo-Classical Styles.* Garden City, NY: Anchor Books, 1976.

Risjord, Norman K. *Thomas Jefferson.* Madison, WI: Madison House, 1994.

Roth, Leland M. *American Architecture: A History.* Boulder, CO: Westview Press, 2000.

Stanton, Lucia. *Those Who Labor for My Happiness: Slavery at Thomas Jefferson's Monticello.* Charlottesville: University of Virginia Press, 2012.

Tallmadge, Thomas E. *The Story of Architecture in America.* New York: W.W. Norton, 1936.

United States Department of the Interior, National Park Service. National Register of Historic Places Registration Form for the capitol of Virginia. May 2005.

Whiffen, Marcus. *American Architecture Since 1780: A Guide to the Styles.* Cambridge, MA: MIT Press, 1988.

Wilson, Richard Guy. "Virginia State Capitol: Additions and Reconstruction Perspective." In *The Making of Virginia Architecture,* edited by Charles E. Brownell. Richmond: Virginia Museum of Fine Arts, 1992.

———. "Thomas Jefferson's Classical Architecture: An American Agenda." In *Thomas Jefferson, the Classical World, and Early America*, edited by Peter S. Onuf and Nicholas P. Cole. Charlottesville: University of Virginia Press, 2011.

TRINITY CHURCH

Eaton, Leonard K. *American Architecture Comes of Age: European Reaction to H. H. Richardson and Louis Sullivan*. Cambridge, MA: MIT Press, 1972.

Floyd, Margaret Henderson. *Henry Hobson Richardson: A Genius for Architecture*. New York: Monacelli Press, 1997.

Kilham, Walter H. *Boston After Bulfinch: An Account of Its Architecture, 1800–1900*. Cambridge, MA: Harvard University Press, 1946.

Larson, Paul Clifford, with Susan M. Brown, eds. *The Spirit of H. H. Richardson on the Midland Prairies*. Ames: Iowa State University Press, 1988.

Meister, Maureen. *H. H. Richardson: The Architect, His Peers, and Their Era*. Cambridge, MA: MIT Press, 1999.

Newman, William A., and Wilfred E. Holton. *Boston's Back Bay: The Story of America's Greatest Nineteenth-Century Landfill Project*. Boston: Northeastern University Press, 2006.

Ochsner, Jeffrey Karl. *H.H. Richardson: Complete Architectural Works*. Halliday Lithograph, 1982.

O'Gorman, James. *H. H. Richardson: Architectural Forms for an American Society*. Chicago: University of Chicago Press, 1987.

———. *Living Architecture: A Biography of H. H. Richardson*. New York: Simon & Schuster, 1997.

O'Gorman, James, ed. *The Makers of Trinity Church in the City of Boston*. Amherst and Boston: University of Massachusetts Press, 2004.

Roth, Leland M. *American Architecture: A History*. Boulder, CO: Westview Press, 2000.

Smit, Kornelis, and Howard M. Chandler, eds. *Means Illustrated Construction Dictionary*. Kingston, MA: R. S. Means Company, 1991.

Whiffen, Marcus. *American Architecture Since 1780: A Guide to the Styles*. Cambridge, MA: MIT Press, 1988.

WAINWRIGHT BUILDING

Andrew, David S. *Louis Sullivan and the Polemics of Modern Architecture*. Urbana: University of Illinois Press, 1985.

Ascher, Kate. *The Heights: Anatomy of a Skyscraper*. New York: Penguin Books, 2011.

Bragdon, Claude. *More Lives Than One*. New York: Alfred A. Knopf, 1938.

Breugmann, Robert. *The Architects and the City: Holabird & Roche of Chicago, 1880–1918*. Chicago: University of Chicago Press, 1997.

Condit, Carl. *American Building*. 2nd ed. Chicago: University of Chicago Press, 1982.

Connely, Willard. *Louis Sullivan: The Shaping of American Architecture*. New York: Horizon Press, 1960.

De Wit, Wim, ed. *Louis Sullivan: The Function of Ornament*. New York: W.W. Norton, 1986.

Goldberger, Paul. *The Skyscraper*. 3rd ed. New York: Alfred A. Knopf, 1983.

Hitchcock, Henry-Russell. *Architecture: Nineteenth and Twentieth Centuries*. Harmondsworth, UK: Penguin Books, 1968.

Hyde, William, and Howard L. Conard, eds. *Encyclopedia of the History of St. Louis*. New York: Southern History Company, 1899.

Levine, Neil. *The Architecture of Frank Lloyd Wright*. Princeton, NJ: Princeton University Press, 1996.

Merwood-Salisbury, Joanna. *Chicago 1890: The Skyscraper and the Model City*. Chicago: University of Chicago Press, 2009.

Morrison, Hugh. *Louis Sullivan: Prophet of Modern Architecture*. New York: W.W. Norton, 1935.

Schmitt, Ronald E. *Sullivanesque: Urban Architecture and Ornamentation*. Urbana: University of Illinois Press, 2002.

Shultz, Earle, and Walter Simmons. *Offices in the Sky*. New York: Bobbs-Merrill, 1959.

Siry, Joseph. "Adler and Sullivan's Guaranty Building in Buffalo." *The Journal of the Society of Architectural Historians* 55, no. 1 (March 1996): 6–37.

Twombly, Robert. *Louis Sullivan: His Life and Work*. New York: Viking, 1986.

Van Zanten, David. *Sullivan's City: The Meaning of Ornament for Louis Sullivan*. New York: W.W. Norton, 2000.

Willis, Carol. *Form Follows Finance: Skyscrapers and Skylines in New York and Chicago*. New York: Princeton Architectural Press, 1995.

Wright, Frank Lloyd. *Genius and the Mobocracy*. New York: Duell, Sloan and Pearce, 1949.

Zukowksy, John. "Introduction to Internationalism in Chicago Architecture." In *Chicago Architecture 1872–1922: Birth of a Metropolis*, edited by John Zukowsky. New York: Prestel, 1987.

ROBIE HOUSE

Alofsin, Anthony. *Frank Lloyd Wright: The Lost Years, 1910–1922: A Study of Influence*. Chicago: University of Chicago Press, 1993.

Banham, Reyner. *The Architecture of the Well-Tempered Environment*. 2nd ed. London: Architectural Press, 1989.

Brooks, H. Allen. *The Prairie School: Frank Lloyd Wright and His Midwest Contemporaries*. New York: W.W. Norton, 1972.

Connors, Joseph. *The Robie House of Frank Lloyd Wright*. Chicago: University of Chicago Press, 1984.

Frampton, Kenneth. "Modernization and Mediation: Frank Lloyd Wright and the Impact of Technology." In *Frank Lloyd Wright: Architect*, edited by Terence Riley. New York: Museum of Modern Art, 1994.

Goldberger, Paul. *Introduction to Frank Lloyd Wright's Robie House*, by Zarine Weil, Cheryl Bachand, and Brian Reis. Seattle: Marquand Books, 2010.

Hitchcock, Henry-Russell. *Architecture: Nineteenth and Twentieth Centuries*. Harmondsworth, UK: Penguin Books, 1968.

Hoffmann, Donald. *Frank Lloyd Wright's Robie House: The Illustrated Story of an Architectural Masterpiece*. New York: Dover, 1984.

Levine, Neil. *The Architecture of Frank Lloyd Wright*. Princeton, NJ: Princeton University Press, 1996.

Manson, Grant Carpenter. *Frank Lloyd Wright to 1910: The First Golden Age*. New York: Van Nostrand Reinhold, 1958.

Pfeiffer, Bruce Brooks. *Frank Lloyd Wright, 1867–1959: Building for Democracy*. Bremen, Germany: Taschen, 2004.

Roth, Leland. *American Architecture: A History*. Cambridge, MA: Westview Press, 2001.

Twombly, Robert C. *Frank Lloyd Wright: His Life and His Architecture*. New York: Wiley, 1979.

Wright, Frank Lloyd. "Organic Architecture Looks at Modern Architecture." *Architectural Record* 111 (May 1952): 148–54.

———. *An Autobiography*. New York: Horizon Press, 1977.

Wright, Gwendolyn. "Architectural Practice and Social Vision in Wright's Early Designs." In *On and by Frank Lloyd Wright: A Primer of Architectural Principles*, edited by Robert McCarter. London: Phaidon, 2005.

———. *Moralism and the Model Home: Domestic Architecture and Cultural Conflict in Chicago, 1873–1913*. Chicago: University of Chicago Press, 1985.

———. "Frank Lloyd Wright and the Domestic Landscape." In *Frank Lloyd Wright: Architect*, edited by Terence Riley. New York: Museum of Modern Art, 1994.

"Wright Terms Doomed Robie House Sound, Hits Plan to Raze Structure." *Chicago Tribune*, March 19, 1957.

HIGHLAND PARK FORD PLANT

Arnold, Horace L., and Fay L. Faurote. *Ford Methods and the Ford Shops*. New York: Engineering Magazine Company, 1915.

Batchelor, Ray. *Henry Ford: Mass Production, Modernism and Design*. Manchester, UK: Manchester University Press, 1994.

Biggs, Lindy. *The Rational Factory: Architecture, Technology, and Work in America's Age of Mass Production*. Baltimore: Johns Hopkins University Press, 1996.

Brinkley, Douglas. *Wheels for the World: Henry Ford, His Company, and a Century of Progress, 1903–2003*. New York: Penguin Books, 2003.

Bucci, Federico. *Albert Kahn: Architect of Ford*. New York: Princeton Architectural Press, 1993.

Burlingame, Roger. *Henry Ford*. Chicago: Quadrangle Books, 1970.

Carter, Brian, ed. *Albert Kahn: Inspiration for the Modern*. Ann Arbor: University of Michigan Museum of Art, 2001.

Chandler, Alfred D. Jr., ed. *Giant Enterprise: Ford, General Motors and the Automobile Industry*. New York: Harcourt Brace, 1964.

Ferry, Hawkins W. *The Legacy of Albert Kahn*. Detroit: Wayne State University Press, 1987.

Hildebrand, Grant. *Designing for Industry: The Architecture of Albert Kahn*. Cambridge, MA: MIT Press, 1974.

The Henry Ford. "History of the Rouge." http://www.thehenryford.org/rouge/historyofrouge.aspx.

Hooker, Clarence. *Life in the Shadows of the Crystal Palace, 1910–1927: Ford Workers in the Model T Era*. Bowling Green, OH: Bowling Green State University Popular Press, 1997.

Hyde, Charles K. "Assembly-Line Architecture: Albert Kahn and the Evolution of the U.S. Auto Factory, 1905–1940." *Journal of the Society for the Industrial Archaeology* 22, no. 2 (1966): 5–24.

Lacey, Robert. *Ford: The Men and the Machine*. Boston: Little, Brown, 1986.

Lee, Albert. *Henry Ford and the Jews*. New York: Stein and Day, 1980.

Miller, Gregory M. *Place, Space, Pace, and Power: The Struggle for Control of the Automobile Factory Shop Floor, 1896–2006*. PhD diss., University of Toledo, August 2008.

Nelson, George. *Industrial Architecture of Albert Kahn, Inc.* New York: Architectural Book Publishing, 1939.

Nevins, Allan. *Ford: The Times, the Man, the Company*. New York: Charles Scribner's Sons, 1954.

Rae, John B. *The American Automobile: A Brief History*. Chicago: University of Chicago Press, 1965.

Sears, Stephen. *The American Heritage History of the Automobile in America*. New York: American Heritage Publishing, 1977.

Sward, Keith. *The Legend of Henry Ford*. New York: Rinehart, 1948.

SOUTHDALE CENTER

"A Break-Through for Two-Level Shopping Centers: Two Level Southdale." *Architectural Forum*, December 1956.

Fest, Joachim. *Hitler*. London: Penguin Books, 1973.

Hardwick, M. Jeffrey. *Mall Maker: Victor Gruen, Architect of an American Dream*. Philadelphia: University of Pennsylvania Press, 2004.

Longstreth, Richard. *City Center to Regional Mall: Architecture, the Automobile, and Retailing in Los Angeles, 1920–1950*. Cambridge, MA: MIT Press, 1997.

Mennel, Timothy. "Victor Gruen and the Construction of Cold War Utopias." *Journal of Planning History* 3, no. 2 (May 2004): 116–50.

Palmer, C. B. "The Shopping Center Goes to the Shopper." *New York Times*, November 29, 1953.

Spielvogel, Carl. "Shopper's Dream Near Completion." *New York Times*, September 24, 1956.

"The Splashiest Shopping Center in the U.S." *Life*, December 10, 1956.

Wall, Alex. *Victor Gruen: From Urban Shop to New City*. Barcelona, Spain: Actar, 2005.

"Weather-Conditioned Shopping Center Opens." *New York Times*, October 9, 1956.

SEAGRAM BUILDING

Blake, Peter. *The Master Builders: Le Corbusier, Mies van der Rohe, Frank Lloyd Wright*. New York: W.W. Norton, 1976.

"Bronze Building to Get 2 Beauty Baths a Year." *New York Times*, March 9, 1958.

Curtis, William J. R. *Modern Architecture Since 1900*. Oxford, UK: Phaidon Press, 1982.

Ennis, Thomas W. "Building Is Designer's Testament." *New York Times*, November 10, 1957.

Etlin, Richard, ed. *Art, Culture and Media under the Third Reich*. Chicago: University of Chicago Press, 2002.

"Five Win Fellowships: Columbia Announces Bestowal of Samuel Bronfman Awards." *New York Times*, November 19, 1954.

Flowers, Benjamin. *Skyscraper: The Politics and Power of Building New York City in the Twentieth Century*. Philadelphia: University of Pennsylvania Press, 2009

Frampton, Kenneth. *Modern Architecture: A Critical History*. London: Thames and Hudson, 1980.

Friedman, Alice T. *American Glamour and the Evolution of Modern Architecture*. New Haven, CT: Yale University Press, 2010.

Goldberger, Paul. *The Skyscraper*. 3rd ed. New York: Alfred A. Knopf, 1983.

Jordy, William H. *The Impact of European Modernism in the Mid-Twentieth Century*. Garden City, NY: Doubleday, 1972.

Kostof, Spiro. *A History of Architecture*. Oxford, UK: Oxford University Press, 1985.

Lambert, Phyllis, ed. *Mies in America*. New York: Harry N. Abrams, 2001.

"No Tie to Rum-Running: Bronfman Brothers' Connection with Rutkin Suit Explained." *New York Times*, March 13, 1954.

NYC Department of City Planning. "About Zoning: Background." http://www.nyc.gov/html/dcp/html/zone/zonehis.shtml.

Saarinen, Aline B. "Pioneer to Design Skyscraper Here." *New York Times*, November 25, 1954.

Schulze, Franz. *Mies van der Rohe: A Critical Biography*. Chicago: University of Chicago Press, 1985.

———. *Philip Johnson: Life and Work*. New York: Alfred A. Knopf, 1994.

———. *The Seagram Building*. New York: Princeton Architectural Press, 1999.

Scott, Felicity. "An Army of Soldiers or a Meadow." *Journal of the Society of Architectural Historians* 70 (September 2011): 330–53.

"Seagram & Sons Has Dip in Profit." *New York Times*, December 28, 1957.

Smith, G. E. Kidder. *Source Book of American Architecture: 500 Notable Buildings from the 10th Century to the Present*. New York: Princeton Architectural Press, 1996.

Spaeth, David. *Mies van der Rohe*. New York: Rizzoli, 1985.

Willis, Carol. *Form Follows Finance: Skyscrapers and Skylines in New York and Chicago*. New York: Princeton Architectural Press, 1995.

DULLES INTERNATIONAL AIRPORT

Century of Flight. "Airlines and Airliners: The Jet Airliner." http://www.century-of-flight.net/new%20site/commercial/jet_liner.htm.

"Dulles International Airport." *Architectural Record* 134 (July 1963): 101–10.

Eames, Charles, and Ray Eames. "The Expanding Airport." *The Films of Charles & Ray Eames*, Volume 5. DVD. Chatsworth, CA: Image Entertainment, 2000.

"Eero Saarinen, 51, Architect, Is Dead." *New York Times*, September 2, 1961.

"Jet-Age Airport." *Time*, February 8, 1960.

"Kennedy and Eisenhower Hail New Dulles Airport." *New York Times*, November 18, 1962.

"Major Airports Note Traffic Rise." *New York Times*, May 1, 1958.

Merkel, Jayne. *Eero Saarinen*. London: Phaidon Press, 2005.

Metropolitan Washington Airports Authority. "History of Washington Dulles International Airport." http://www.mwaa.com/dulles/661.htm.

"A New Airport for Jets." *Architectural Record* 127 (March 1960): 175–82.

Pearman, Hugh. *Airports: A Century of Architecture*. London: Laurence King Publishing, 2004.

Pelkonen, Eeva-Liisa, and Donald Albrecht, eds. *Eero Saarinen: Shaping the Future*. New Haven, CT: Yale University Press, 2006.

"Portico to the Jet Age," *Architectural Forum*, July 1963.

"President Backs New Airport Site." *New York Times*, January 15, 1958.

Roman, Antonio. *Eero Saarinen: An Architecture of Multiplicity*. New York: Princeton Architectural Press, 2003.

Saarinen, Aline. *Eero Saarinen on His Work*. New Haven, CT: Yale University Press, 1962.

"Saarinen's Terminal Building at the Dulles International Airport." *Architectural Forum*, September 1961.

VANNA VENTURI HOUSE

Brownlee, David B., David G. Delong, and Kathryn B. Hiesinger, eds. *Out of the Ordinary: Robert Venturi, Denise Scott Brown and Associates*. Philadelphia: Philadelphia Museum of Art, 1999.

Schwartz, Frederic. *Mother's House: The Evolution of Vanna Venturi's House in Chestnut Hill*. New York: Rizzoli, 1992.

Venturi, Robert. *Complexity and Contradiction in Architecture*. 2nd ed. New York: Museum of Modern Art, 2002.

WALT DISNEY CONCERT HALL

Chong, Jia-Rui. "Disney Hall Glare Gets to Neighbors." *Los Angeles Times*, February 21, 2004.

Gehry, Frank, et al. *Symphony: Frank Gehry's Walt Disney Concert Hall*. New York: Harry N. Abrams in Association with the Los Angeles Philharmonic, 2003.

Giovannini, Joseph. "Frank Gehry, Public Artist." *Art in America* 92, no. 10 (November 2004).

Isenberg, Barbara. *Conversations with Frank Gehry*. New York: Alfred A. Knopf, 2009.

"New LA Concert Hall Raises Temperatures of Neighbors." *USA Today*, February 24, 2004.

Pastier, John. "Gehry's Disney Hall: Does It Deserve the Hosannas?" *Architectural Record* 192, no. 1 (January 2004).

Ragheb, J. Fiona, ed. *Frank Gehry, Architect*. New York: Solomon R. Guggenheim Foundation, 2001.

Russell, James S. "Project Diary: The Story of How Frank Gehry's Design and Lillian Disney's Dream Were Ultimately Rescued to Create the Masterful Walt Disney Concert Hall." *Architectural Record* 191, no. 11 (November 2003): 134–51.

PHOTO CREDITS

COVER Steve Smith

BACK COVER (clockwise from top left)
Jonathan Nestor, Katherine Castro, Kelly Manteck, Rory Thomas O'Neill, Antony Platt, Steve Smith, Steven Goldblatt, Peter Reitzfeld, Justin Maconochie, William Zbaren

TITLE PAGE p. 2: Jonathan Nestor

INTRODUCTION p. 6-7: Peter Reitzfeld

CHAPTER 1

pp. 10-11: Jonathan Nestor

p. 12: Library of Congress, Prints and Photographs Division, LC-USZ62-75384 DLC

pp. 12-13: Chicago History Museum

p. 14: Library of Congress, Prints and Photographs Division, Detroit Publishing Company Collection

p. 15 (top): Jonathan Nestor

p. 15 (bottom): Library of Congress

pp. 16-17: Jonathan Nestor

p. 18 (top): Library of Congress

p. 18 (bottom): Jonathan Nestor

pp. 19-21: Jonathan Nestor

CHAPTER 2

pp. 22-23: Katherine Castro

p. 24 (left): Shepley Bulfinch Richardson and Abbott

p. 24 (right): © CORBIS

p. 25: Library of Congress

p. 26 (left): Library of Congress

p. 26 (right): Library of Congress, Prints and Photographs Division, LC-DIG-pga-00232

pp. 27-33: Katherine Castro

CHAPTER 3

pp. 34-36: William Zbaren

p. 37 (left, top): Library of Congress, Prints and Photographs Division, HABS MO,96-SALU,49-39

p. 37 (left, bottom): Library of Congress, Prints and Photographs Division, HABS MO,96-SALU,49-38

p. 37 (right): The Art Institute of Chicago

p. 38: William Zbaren

p. 39: Library of Congress, Prints and Photographs Division, HABS MO,96-SALU,49-3

pp. 40-44: William Zbaren

p. 45 (left): Library of Congress, Prints and Photographs Division, HABS MO,96-SALU,49-10

pp. 45-47 (right): William Zbaren

CHAPTER 4

pp. 48-49: Kelly Manteck

pp. 50-51: Courtesy of the Frank Lloyd Wright Preservation Trust, Chicago, IL

pp. 52-63: Kelly Manteck

CHAPTER 5

pp. 64-65: Justin Maconochie

p. 66 (left, top): Library of Congress, Prints and Photographs Division, HAER MI-347-1

p. 66 (left, bottom): Library of Congress, Harris & Ewing Collection

p. 66 (right, top): Albert Kahn Associates, Inc.

p. 66 (right, bottom): Library of Congress

p. 67–69: Albert Kahn Associates, Inc.

pp. 70-74: Justin Maconochie

p. 75: Albert Kahn Associates, Inc.

CHAPTER 6

pp. 76-77: Rory Thomas O'Neill

p. 78: Victor Gruen Papers, American Heritage Center, University of Wyoming

p. 79: Minnesota Historical Society

pp. 80-81: Time & Life Pictures/Getty Images

p. 82: Rory Thomas O'Neill

p. 83: Simon Property Group

pp. 84-85: Rory Thomas O'Neill

CHAPTER 7

pp. 86-87: Peter Reitzfeld

p. 88 (top): Peter Reitzfeld

p. 88 (middle): Hagley Museum and Library

p. 88 (bottom): Chicago History Museum

p. 89-93: Peter Reitzfeld

p. 93 (top): Fonds Phyllis Lambert, Canadian Centre for Architecture, Montreal. © United Press International

p. 94-99: Peter Reitzfeld

CHAPTER 8

pp. 100-101: Antony Platt

p. 102 (top): Library of Congress, Prints and Photographs Division, The Work of Charles and Ray Eames, photo by Bernice Clark

p. 102 (bottom): Getty Images

pp. 103-106: Antony Platt

p. 107: The Art Institute of Chicago

p. 108-109: Antony Platt

pp. 110: Photographs in the Carol M. Highsmith Archive, Library of Congress, Prints and Photographs Division

pp. 110-111: Antony Platt

CHAPTER 9

pp. 112-115: Steven Goldblatt

p. 115 (bottom): Venturi, Scott Brown and Associates, Inc.

p. 116: Steven Goldblatt

p. 117: Venturi, Scott Brown and Associates, Inc.

pp. 118-121: Steven Goldblatt

CHAPTER 10

pp. 122-127: Steve Smith

p. 128: Berliner Studio/BEImages

p. 129: Hufton + Crow / View Pictures/Rex USA

pp. 130-133: Steve Smith

ACKNOWLEDGMENTS

p. 143: Steven Goldblatt

ABOUT THE AUTHORS

p. 144: Justin Maconochie

EXPERT CONTRIBUTORS

Mina M. Chow
Lecturer
University of Southern California
School of Architecture

Tom Fisher
Professor and Dean of the College of Design
University of Minnesota

Alice T. Friedman
Grace Slack McNeil Professor of American Art
Wellesley College

Paul Goldberger
Architecture Critic
Vanity Fair

Annette Gordon-Reed
Professor of History
Harvard University

Charles K. Hyde
Professor Emeritus
Wayne State University

Reed Kroloff
Director
Cranbrook Academy of Art and Art Museum

Ted Landsmark
President and CEO
Boston Architectural College

Barry Lewis
Architectural Historian

Martin Moeller
Senior Curator
National Building Museum

James F. O'Gorman
Grace Slack McNeil Professor Emeritus
of the History of American Art
Wellesley College

Tim Samuelson
Cultural Historian for the City of Chicago

Michael Webb
Architecture Writer

Richard Guy Wilson
Professor of Architectural History
University of Virginia

Gwendolyn Wright
Professor of Architecture at Columbia
University and Contributor to the PBS
series *History Detectives*

CHAPTER 6

pp. 76-77: Rory Thomas O'Neill

p. 78: Victor Gruen Papers, American Heritage Center, University of Wyoming

p. 79: Minnesota Historical Society

pp. 80-81: Time & Life Pictures/Getty Images

p. 82: Rory Thomas O'Neill

p. 83: Simon Property Group

pp. 84-85: Rory Thomas O'Neill

CHAPTER 7

pp. 86-87: Peter Reitzfeld

p. 88 (top): Peter Reitzfeld

p. 88 (middle): Hagley Museum and Library

p. 88 (bottom): Chicago History Museum

p. 89-93: Peter Reitzfeld

p. 93 (top): Fonds Phyllis Lambert, Canadian Centre for Architecture, Montreal. © United Press International

p. 94-99: Peter Reitzfeld

CHAPTER 8

pp. 100-101: Antony Platt

p. 102 (top): Library of Congress, Prints and Photographs Division, The Work of Charles and Ray Eames, photo by Bernice Clark

p. 102 (bottom): Getty Images

pp. 103-106: Antony Platt

p. 107: The Art Institute of Chicago

p. 108-109: Antony Platt

pp. 110: Photographs in the Carol M. Highsmith Archive, Library of Congress, Prints and Photographs Division

pp. 110-111: Antony Platt

CHAPTER 9

pp. 112-115: Steven Goldblatt

p. 115 (bottom): Venturi, Scott Brown and Associates, Inc.

p. 116: Steven Goldblatt

p. 117: Venturi, Scott Brown and Associates, Inc.

pp. 118-121: Steven Goldblatt

CHAPTER 10

pp. 122-127: Steve Smith

p. 128: Berliner Studio/BEImages

p. 129: Hufton + Crow / View Pictures/Rex USA

pp. 130-133: Steve Smith

ACKNOWLEDGMENTS

p. 143: Steven Goldblatt

ABOUT THE AUTHORS

p. 144: Justin Maconochie

EXPERT CONTRIBUTORS

Mina M. Chow
Lecturer
University of Southern California
School of Architecture

Tom Fisher
Professor and Dean of the College of Design
University of Minnesota

Alice T. Friedman
Grace Slack McNeil Professor of American Art
Wellesley College

Paul Goldberger
Architecture Critic
Vanity Fair

Annette Gordon-Reed
Professor of History
Harvard University

Charles K. Hyde
Professor Emeritus
Wayne State University

Reed Kroloff
Director
Cranbrook Academy of Art and Art Museum

Ted Landsmark
President and CEO
Boston Architectural College

Barry Lewis
Architectural Historian

Martin Moeller
Senior Curator
National Building Museum

James F. O'Gorman
Grace Slack McNeil Professor Emeritus
of the History of American Art
Wellesley College

Tim Samuelson
Cultural Historian for the City of Chicago

Michael Webb
Architecture Writer

Richard Guy Wilson
Professor of Architectural History
University of Virginia

Gwendolyn Wright
Professor of Architecture at Columbia
University and Contributor to the PBS
series *History Detectives*

ACKNOWLEDGMENTS

This book is based on the PBS special "10 Buildings that Changed America," a production of WTTW Chicago.

Major funding was provided by The Negaunee Foundation, ITW, Robert & Joan Clifford, and BMO Harris Bank.

Generous support was also provided by the Joseph & Bessie Feinberg Foundation, Rande & Cary McMillan, Richard & Mary L. Gray, The Robert Thomas Bobins Foundation, Alexandra & John Nichols, The Walter E. Heller Foundation, in memory of Alyce DeCosta, and Nicor Gas.

Additional funding was provided by Harriet K. Burnstein, Ken Norgan, Peter Kelliher II, Millennium Properties, Perkins+Will, USG Corporation, and Neil G. Bluhm (as of 2/14/13).

We gratefully acknowledge:

Jean Guarino, Researcher

The Chicago History Museum

The Society of Architectural Historians

Doug Seibold, Kate DeVivo, and the team at Agate Publishing

And our wives, Emily Friedman and Amelia Kohm

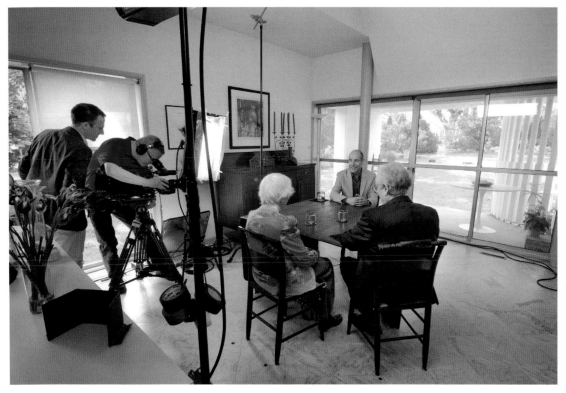

Producer Dan Protess (left) and Director of Photography Tim Boyd (second from left) as Geoffrey Baer interviews architects Robert Venturi and Denise Scott Brown.

ABOUT THE AUTHORS

DAN PROTESS has been producing and writing critically acclaimed television programs and films for two decades. His work has appeared on PBS, ABC, C-SPAN, and at film and video festivals across the country. Dan has produced or written 14 documentaries for WTTW Chicago, including the award-winning *A Justice That Heals, Biking the Boulevards*, and *The Foods of Chicago: A Delicious History*, which earned him an Emmy and a James Beard Award nomination. He won a Peter Lisagor Award for his work on *Chicago Tonight*, the station's nightly newsmagazine program. He lives in Chicago.

GEOFFREY BAER is a familiar face to Chicago television audiences for his Emmy award-winning programs about the city's architecture and history on PBS station WTTW. Over a 35-year career he has produced, written, and hosted hundreds of programs for PBS, national syndication, and local stations around the country. He has taught improv theater and high school drama in Chicago and given countless tours as a docent for the Chicago Architecture Foundation. He has been honored by the Corporation for Public Broadcasting, the Society of Architectural Historians, the Chicago Headline Club, and many others.